Baltimore Album Revival!

Historic Quilts in the Making

by Elly Sienkiewicz

Catalog of C&T Publishing's
Baltimore Album Revival Quilt Show
and Contest

Lancaster Host Hotel, Lancaster, Pennsylvania
April 7-10, 1994

C&T PUBLISHING

This historic exhibition honors the old made new again. It is a tribute to the Revivalist Baltimores, to their makers, and to *Baltimore Beauties and Beyond, Studies in Classic Album Quilt Appliqué,* the nine-book series by Elly Sienkiewicz. Quiltmakers' imaginations were caught by her first book, *Spoken Without a Word* (1983), which introduced the symbolism threading through Baltimore's Album Quilts. But it is her *Baltimore Beauties* series (1989-1995) which has sustained a Baltimore Album Revival of impressive proportions. Self-taught by the *Baltimore Beauties* books, or taught through them by talented teachers, great numbers of modern quiltmakers have mastered the intricacies of this classic mid-19th-century art needlework and caused the style's full-scale revival. Album Quilts, reborn, are once again a brilliantly expressive medium. With this Baltimore Album Revival Exhibition, C&T Publishing celebrates these historic quilts-in-the-making and applauds their creators.

This Exhibit Catalog includes:

· Biographical Sketches of the Judges and the Judging Philosophy

· Contest Categories

· All Teachers nominated for the Honored Teacher Award

· Underlinings and Marginalia: Literary quotes to highlight the Album Quilts' magic

· Essay (Introductory Remarks at the Exhibition) "Myth, Dreams, Metaphors, and Magic: Album Quilts at Exhibition"

· Color Portraits of 21 Albums

· The *Baltimore Beauties* Needleartists' Group Quilts

· The Quilts juried in and hung in the exhibition (annotated by quotes from their makers)

· About the author and the *Baltimore Beauties* series

©1994 by Eleanor Patton Hamilton Sienkiewicz

Photography by Sharon Risedorph.

Editing by Louise Owens Townsend.

Technical editing by Joyce Engels Lytle.

Design by Bobbi Sloan Design, Berkeley, California.

Published by C&T Publishing, P. O. Box 1456, Lafayette, California 94549.

ISBN 0-914881-77-9

The cover photo is a detail from Quilt No. 727, A Tribute to Celia Thaxter (1835-1894) by Faye Samaras Labanaris of Dover, New Hampshire. 1993. A photo of the whole quilt is included in this catalog on page 26.

Printed in the United States of America

First Edition

10 9 8 7 6 5 4 3 2 1

The enthusiasm and superb artistry of the Album Quilt-makers have made C&T's Revivalist Baltimore Exhibition possible. Quilts including some of the blocks made by the *Baltimore Beauties* needleartists also grace this exhibition. While most of these needleartists have already been featured in the *Baltimore Beauties* series, the brief biographies of some whose work is in these group quilts will first appear in *Volume III.* My special thanks to each quiltmaker who gifts us at this show. My appreciation to C&T Publishing, publishers of the *Baltimore Beauties* series endures—Thank you, once again! And to all those at C&T Publishing who made this exhibition possible—thank you.

This catalog rides on careful quilt documentation overseen by Louise Townsend, its editor, and for all her input I am most grateful, as I am to Bobbi Sloan who designed it, and to Joyce Lytle who did the technical editing.

We at C&T Publishing thank Rita Barber, President of Barber Diversified, for providing a superb forum for this exhibition in her annual conference, the Quilters' Heritage Celebration, in Lancaster. Thank you, too, to author Joen Wolfrom *(Landscapes and Illusions, Magical Effects of Color)* and to P & B Textiles' Creative Director, Jennifer Sampou, for joining C&T Publishing in jurying the quilts for this show. And, thank you to Sharon Pilcher, C&T's Marketing Manager, who gathered the show's sponsors, to whom we also offer our warm thanks. Those sponsors are: Bernina of America, Inc.; Fairfield Processing Corporation; Fiskars Manufacturing Corporation; Keepsake Quilting; P & B Textiles, Inc.; *Quilter's Newsletter Magazine;* Quilters' Resource Inc.; and Therm-O-Web. Thank you so very much, too, to our judges, Bonnie Leman, Editor-in-Chief of *Quilter's Newsletter Magazine,* and Mary Roby, Managing Editor of *Country Living.* The gift of their time and talent does us all honor.

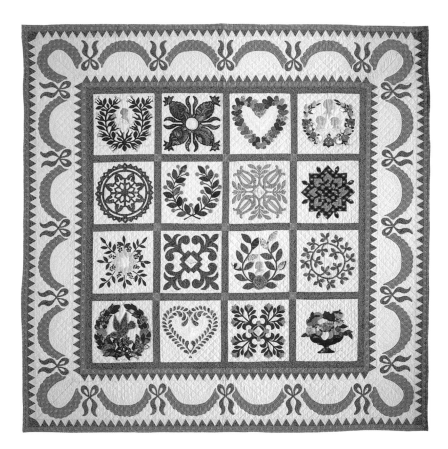

726. BALTIMORE
by Vivian Kruzich
of Trussville, Alabama.
1990–1992. 84" x 84".

The Contest

Having decided in 1992 to celebrate the *Baltimore Beauties* series with a gala show, C&T Publishing penned a Quilt Show Philosophy. Then it invited two prominent magazine editors to join with author Elly Sienkiewicz in judging the show. We are delighted that they accepted the invitation and introduce these judges, and then the judging philosophy, here.

The Judges

BONNIE LEMAN, EDITOR-IN-CHIEF, *Quilter's Newsletter Magazine*

For 25 years, since Bonnie and George Leman began it in 1969, *Quilter's Newsletter Magazine* has inspired and chronicled the enthusiasm of the late-20th century's quiltmaking revival. So vital a binding cord has "QNM" been, that quiltmakers now see themselves as a cohesive—though feisty and individualistic—whole.

As *Quilter's Newsletter Magazine* grew and changed from a thin black-and-white "newsletter" to a glossy and color-filled magazine, so the Leman family grew. Back in 1968, an industrious young mother, Bonnie Leman, had six children (the oldest was 13) and a small quilt pattern business called "Heirloom Plastics." With her seventh and last child, Matt, on the way, Bonnie launched her *Newsletter* in 1969. Inspired by her mother, a collector of *Kansas City Star* patterns, and her quiltmaking aunt, aided by her husband and the older Leman children, Bonnie's *Newsletter* prospered until, like the quilt hobby industry it fostered, it became a realization of the American dream. Now one among many quilt magazines, *Quilter's Newsletter Magazine* remains uniquely gratifying and well-loved. Month after month, year after year, quiltmakers open to "The Needle's Eye" to read Bonnie's thoughtful commentary on their "quilt world." Around the world, quilters feel they have a special quilting friend to whom they write with regularity and whose news they wait to read, having been bid, "Until next time, Happy Quilting."

MARY ROBY, MANAGING EDITOR, *Country Living*

For many years now, *Country Living* has defined for us all our love of American Country style and all that that has come to mean. With lush photography and an almost poetic presentation, it pictures homes across the country where quilts abide. It's safe to say that *Country Living* is the quiltmakers' favorite "scene-setting" magazine. The *Country Living* person who, since 1986, has been writing about quilts with a contagious enthusiasm, is Managing Editor Mary Roby.

Mary's publishing career began in 1968 at Simplicity Pattern Company's Educational Department where she wrote and produced home-sewing brochures and books. From Technical Editor at *Ladies' Home Journal Needle & Craft* magazine in 1971, Mary became *American Home Crafts'* Managing Editor in 1972. She came on board the newly launched *Country Living* in 1979 in the capacity of Managing Editor. Writing her eagerly anticipated column on quilting and her special features on how-to topics are just some of the hats she wears as an administrator for that thriving publication. Mary's other interests include the study of antiques, especially painted furniture and textiles, a fondness for jazz and blues, and, of course, a love for quilts.

The Quilt Show Philosophy

C&T Publishing has become aware that many quilts highly valued in the art and antique world could not win Best of Show when judged by some of our contemporary judging standards. Such judging philosophies tend to devalue for technical details rather than seeing the whole as greater than the sum of its parts. Such judging standards may create a disconcerting discrepancy between quilts seen as craft and quilts seen as art.

For almost a decade, the most renowned 19th-century Album Quilts have been valued

at the sort of prices commanded by real estate. Yet, judged by widely espoused standards today, these quilts might to a one, not even place. The antique appliqué Album Quilts have appealed widely to quiltmakers of diverse talents and inclinations. We hope our judging will reflect this and commend that which makes a quilt most memorable.

Thus, our judging criteria for workmanship asks: Does the quilt inspire, fill one with admiration and pleasure? If the answer is yes, then its workmanship has been eminently successful. But no quilt shall be devalued for technical details, which do not detract from the quilt's overall impression. We seek to reward for timeless qualities, for the impression the quilt conveys as a work of art.

In the end, judging is just that: a best-effort, considered opinion. The judges will give and take, then arrive at consensus winners in the time allotted. Each judge will have an opportunity to present a Judge's Choice to reward one more quilt she loved but which did not finish among the winners.

But the majority—wonderful quilts all—won't receive special mention. C&T Publishing wishes to note the important point: Each of these Album Quilts, even those not juried into the show, is truly a winner—now and for posterity. With enviable passion and artistry, each quiltmaker has given new life to a classic and particularly expressive antique quilt style. Thank you for entering the show, and thank you for bringing appliqué Albums to bloom again in the late-20th Century—for taking Baltimore beautifully "beyond."

Elly Sienkiewicz, Author,
Baltimore Beauties and Beyond Series

Todd Hensley, President,
C&T Publishing

Contest Categories

I. REVIVAL OF A CLASSIC STYLE (sponsored by P & B Textiles, Inc.): A classic style is first learned and its principles understood by faithful reproduction. The award for Revival of a Classic Style applauds this accomplishment.

II. BEAUTIFULLY INNOVATIVE (sponsored by *Quilter's Newsletter Magazine)*: The award for Beautifully Innovative is given in recognition of a quilt, which takes the classic Baltimore style beautifully "beyond."

III. REFLECTIVE OF PARTICULAR LIVES AND TIMES (sponsored by Fiskars Manufacturing Corporation): In her first book on these quilts, *Spoken Without a Word*, Elly Sienkiewicz wrote that these quilts were "a window into the soul of the women who made them." The award for Reflective of Particular Lives and Times is given for a quilt particularly expressive of the maker or of the person or theme the quilt was designed to commemorate.

Special Awards

BEST OF SHOW MADE PREDOMINANTLY BY HAND (sponsored by Fairfield Processing Corporation): Deemed Best of Show by a consensus of the judges, this award commends the Revivalist Baltimore Album style quilt done predominantly by hand.

BEST OF SHOW MADE PREDOMINANTLY BY MACHINE (sponsored by Bernina of America, Inc.): Deemed Best of Show by a consensus of the judges, this award commends the Revivalist Baltimore Album style quilt done predominantly by machine.

JUDGE'S CHOICE AWARD (sponsored by Therm-O-Web): Each of the three judges will have an opportunity to reward a quilt she considers particularly worthy but which does not rank among the first, second, or third place winners in the categories mentioned above.

PUBLISHER'S CHOICE (sponsored by C&T Publishing): C&T Publishing will present the

publisher's choice award for its favorite Baltimore Album style quilt.

VIEWERS' CHOICE (sponsored by Keepsake Quilting): Those present at the Quilters' Heritage Celebration in Lancaster, Pennsylvania, in April 1994 will have an opportunity to cast their ballots for The Viewers' Choice Award.

HONORED TEACHER (sponsored by Quilters' Resource Inc.): In this catalog, C&T would like to honor the many teachers of the Baltimore style who have made it bloom so gloriously once again in his or her region of the country and of the world. We asked how teachers have affected your work and the work of others in your area. The honored teachers, who are listed at the right, have received the greatest number of nominations from admiring students.

404. DEO SOLI GLORIA ["TO GOD ALONE GIVE GLORY"] by Cindy Notarianni Swainson of Scarborough, Ontario, Canada. 1990-1992. 83½" x 93½".

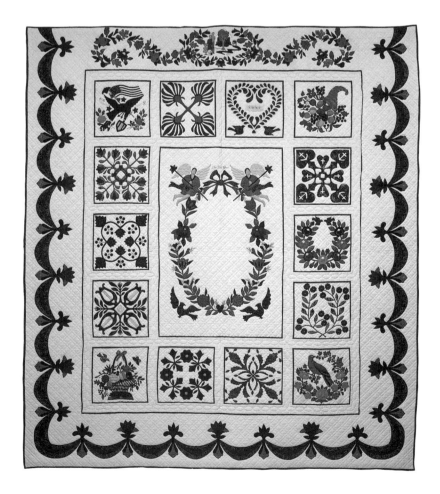

Lillian Arnold of Bend, Oregon
Shirley Brabson of Albuquerque, New Mexico
Stephanie Braskey of Pottstown, Pennsylvania
Lucy K. Brown of Rochester, Minnesota
Pat Brown of Colonia, New Jersey
LaDonna Christensen of Los Osos, California
Sherry Cook of Emporia, Kansas
Patricia Cox of Minneapolis, Minnesota
Mimi Dietrich of Baltimore, Maryland
Zolalee Gaylor of Midwest City, Oklahoma
Vickie Jones of Rushville, Indiana
Beth Thomas Kennedy of Austin, Texas
Gail Kessler of Oley, Pennsylvania
Faye Labanaris of Dover, New Hampshire
Sue Linker of Sumner, Washington
Letty Martin of Lake Orion, Michigan
Carol Ann Matthews of Canton, Michigan
Marjorie McKewen of Kingaroy, Australia
Ruth H. Meyers of Dhahran, Saudi Arabia
Anne Morrison of Winnipeg, Manitoba, Canada
Sue Orleman of Pittsburgh, Pennsylvania
Marlene Peterman of West Hills, California
Susan Plack of El Cajon, California
Linda Plyler of Mason, Michigan
Barbara Pudiak of Fairport, New York
Sheryl Morrow Robinson of Pittsburgh, Pennsylvania
Lisa Schiller of Houston, Texas
Dale B. Schofield of Ossipee, New Hampshire
Joyce Selin of Stone Mountain, Georgia
Laurene Sinema of Phoenix, Arizona
Louisa Smith of Walpole, Massachusetts
Robin Stewart of Allentown, New Jersey
Donna Stypczynski of Berea, Ohio
Cindy Notarianni Swainson of Scarborough, Ontario, Canada
Cathy Swank of Mansfield, Ohio
Wynette Thien of Bridgewater, New Jersey
Nadine Thompson of Pleasanton, California
Juanita Whiting of Woodstock, Illinois
Shirley Wolk of Salina, Kansas

Myth, Dreams, Metaphors and Magic: Album Quilts at Exhibition

These were the introductory remarks given by Elly Sienkiewicz at the Press Preview Party just prior to the opening of C&T Publishing's Baltimore Album Revival Exhibition, held at the Lancaster Host Hotel, Lancaster, Pennsylvania, from April 7 to 10, 1994.

GOOD EVENING AND WELCOME! Thank you all so much for coming to our party, for coming to our exhibition. It's a particular pleasure to address you at this festive tribute to Revivalist Baltimore Album Quilts. Thank you, too, to Rita Barber whose Quilters' Heritage Celebration provides the forum for our show. And thank you to our Contest Judges, Bonnie Leman of *Quilter's Newsletter Magazine,* and Mary Roby of *Country Living.* Thank you to our hosts here, my publisher, C&T Publishing, represented tonight by its President, Todd Hensley. As you may know, I have had the great good fortune to have C&T as my publisher for the *Baltimore Beauties and Beyond* series. Their commitment to publish the series has abided as my interest in these quilts has deepened. My second book on these classic quilts, *Baltimore Beauties and Beyond, Studies in Classic Album Quilt Appliqué, Volume I,* has, since the series was begun in 1989, mushroomed (nourished by these old quilts' unfolding secrets) into seven books so far.

A bit to my amazement, as I became captivated by the antebellum Baltimores, so did growing numbers of quiltmakers both across the country and around the world. Considering the question "What is this fascination with the Baltimore Album style?" seems an appropriate introduction to viewing this much anticipated quilt show. We must ask, too, why so many international citizens currently find creation in the appliquéd Album format not only intriguing, but downright compelling. What meaning, what pleasure, what impetus to self-expression, what search for solace has brought these quilts to life? What magic of heart and mind and hand has appliquéd such beauty into these Album Quilts?

Perhaps these are unanswerable questions! But let's consider them just briefly, as a background melody for viewing these stitched and showcased glories. "Only through Art," wrote Marcel Proust, "can we emerge from ourselves and know what another sees." To begin our visit, then, let's slip back a century and more, and breathe, for a moment, the ether of earlier times. A gentleman named Edward Everett, in an address at Buffalo, New York, on October 9, 1857, phrased an appealing thought: "As a work of art," he began, "I know few things more pleasing to the eye, or more capable of affording scope and gratification to a taste for the beautiful, than a well-situated well-cultivated farm." Wedding both art and craft, that quote seems wonderfully applicable here in Lancaster, surrounded by Pennsylvania's rolling farmfield patchwork.

May I speak for us all and say that we ourselves know few things more pleasing to the eye, or more gratifying to a taste for the beautiful, than a well-laid-out, well-stitched quilt? For as surely as the plowman follows his calling to sow and to reap, tilling the land for food, quiltmakers heed their craft's pull to stitch and to harvest the fruit of their needle's art. These quilts we make are sustaining fruit, capable of nourishing souls as surely as farmers' wheat nourishes bodies.

Vintage political philosophy, too, smiles on our likening a quilt's pleasing quality to that of a well-laid-out farm. Some two centuries ago, Thomas Jefferson favored an agrarian economy for his young country, arguing that land ownership gave citizens a sense of freedom and independence. Moreover, he believed that the occupation of farming, a way of life tied close to nature, would nurture man's innately good human character, his moral nature, and his common sense. By the same logic, could we not argue, that Album Quilt-making gives one a sense of freedom and independence, ties one close to nature, and is good for democracy? [(Aside) You can rest easy now; that's as close as I come to discussing politics!] Both farming and Album Quilt-making are complex undertakings requiring a dream—a vision of the whole—and a square-by-square approach to accomplishing the task.

AUTHOR'S UNDERLININGS & MARGINALIA

Myth ...
is an imagery in terms
of which we make
sense out of life. ...
The image always
has a more powerful
influence on our feel-
ings than abstract and
sophisticated ideas....
Mythology is not a
peripheral manifesta-
tion, not a luxury,
but a serious attempt
at integration of
reality and experience.
— Ira Progoff,
Waking Dream and
Living Myth

AUTHOR'S NOTE

Are Album Quilts for us a mythology? Does their imagery, their making, help us make sense out of life? Our ritual repetition of symbolic designs does have the tenor of rite. Appliqué's monotonous Tack Stitch does have a peaceful rhythm, a meditative quality.... Quiltmaking is a comfort; does staunch a hunger....

Jefferson suggests that as the farmer cultivates the soil, something is cultivated within the farmer, himself: something transforming, something "magical" happens to him. Does quiltmaking similarly transform the quiltmaker? Ask almost any Album Quilt-maker and she will say that it is so. Science has long proceeded on the assumption that the whole is equal to the sum of its parts. Yet we know that in certain endeavors—in art or in sports for example—the whole can be much more. Five boys playing basketball don't necessarily constitute a Team with a capital "T." A Team is much more than the sum of its parts. It creates something magical.

A great quilt, too, is more than the sum of its parts. As we wait for the quilt show doors to open, we must all be curious about what we'll see. When we contemplate these quilts, each of us will most likely be weaving a braid, a cord of judgment composed of some version of these three questions: 1. "What do these works of art, these Revivalist Baltimore Album Quilts actually look like?" 2. "While the artist was making this work of art, was she affected by the process? Did something magical happen to her?" And 3. "When we, the audience, see these quilts how do they affect us? Will some of that magic be conveyed to us?" For we can hypothesize that to the degree to which a quilt affects its viewer, to that degree the quilt is more art than craft.

Tonight, an evening in nature's most optimistic season, we're here to celebrate Baltimore-style Album Quilts. We come in tribute both to modern masterpieces and to heirlooms made a century and a half ago. The year 1994 draws us close to the cusp of our own century's turn. And thus the time, the place, and the occasion seem auspicious. In choosing both an exhibition and a competition as the arena for our festivities, C&T Publishing echoes a mid-19th-century host, The Maryland Institute for the Promotion of the Mechanic Arts. The Institute displayed Baltimore's Album Quilts at a series of major annual exhibitions. Beginning with the first exhibit in 1848, they, too, produced a catalog of "articles deposited at the exhibition," and included, thereafter, the annual opening and closing addresses. Baltimore Albums thus thread our century to its predecessors, and they will, we have to believe, piece these centuries, past and present, to those yet to come.

To identify the quilts we fête tonight, Cleda Jeannette Dawson, curator of 1992's Great Baltimore Revival show in Jefferson, Oregon, coined the term "Revivalist Baltimore Albums." This name seems to suit them best. It does honor to their antebellum roots while recognizing the inventiveness of a style come freshly into its own. As all Albums (whether record albums, stamp albums, autograph or photograph albums) are collections on a theme, so Album Quilts are collections of blocks, most appliquéd, on a theme. Today's Albums include both faithfully reproduced traditional motifs, many used intentionally for their symbolic meanings, and original designs with meanings of their own.

In popular usage, the term "Baltimore Album Quilts" has become a rather loose one, an evolution that may already have begun in the era of their making. By name and by geography, classic Baltimore Album Quilts of the 1840s through the mid-1850s, have always been tied most directly to Baltimore, Maryland. But even in the mid-19th Century we perceive the style as dynamic and contagious. In varying degrees, elements of the style extended beyond Baltimore and metamorphosed, reflecting grand historic change as well as the individual stitchers' particular history. It blended with Album styles well north, south, and west of the city that lent it its name.

The incorporation of appliquéd symbols—those visible signs of invisible things—is fundamental to the Baltimore Album style. Inclusion of the symbolic tongue, in fact, characterizes the whole of Victorian literary, musical, and material culture. But it is the fraternal symbols, in particular—those of the Masons, and especially those of America's Baltimore-centered Odd Fellows—which blaze such a visible and far-reaching trail of Album-style influence. If one traces in the Albums only the Odd Fellow's Three-Linked Chain symbol (for "Friendship, Love, and

Truth") or the Rebekah's Dove emblem, their stylistic trail winds well beyond Maryland. The appliqués seem both to have been inspired by, and to decorate Independent Odd Fellowdom's meteoric rise in popularity in this country.

Let me, at this point, sketch just the briefest reference frame, so that both those who already know and love Baltimore-style Albums well, and those first meeting the style this evening, will share some common footing. This show's catalog is my seventh book on the Baltimore-style Albums, which is simply to say that my love for them has been both ardent and enduring. I won't even attempt to repeat here what those books try to impart about the classic Baltimore Album Quilts. This is not the time to focus on their brilliant Victorian needlework threads; nor is it the place to examine their bright snatches of political and cultural history; nor will I try, tonight, to do much more than recall for you the warp of momentous social change (so similar to our own society today) upon which this rich Album tapestry was woven. We can only mention the massive waves of immigration, and the disintegration of the family-centered economy as industrialization and urbanization changed the very texture of those quiltmakers' cloth.

The need for fellowship, for common values, and for a sense of belonging was increasingly served not as it had been, by extended families, but by expanding institutions: churches, fraternal orders, friendly benefit societies, and educational institutions like the Maryland Institute for the Promotion of the Mechanic Arts. I personally believe Baltimore's antebellum quiltmakers stitched their old world's symbols together with emblems of the new. I believe that by their quiltmaking they navigated the shoals of societal change and transited safely to firm ground. I might wonder aloud, tonight, whether we are presently witnessing Album Quilt-making's healing ritual repeated once again. Let me share just a few hypotheses with you, about why quiltmakers today seem to be so taken by this antebellum style. For you will see that they are learning this classic style's intricacies well, and some

already have gone on to something quite "beyond Baltimore," quite distinctly and evocatively their own.

I first met numbers of the "classic Baltimores," these fascinating ladies, in person at the Baltimore Museum of Art's 1982 exhibition. Immediately and forcefully, their bright beauty drew me to them. Irresistibly, a sense that they were windows to the soul of the women who made them, intrigued me. And an intuition that they spoke in a forgotten symbolic tongue led, in 1983, to *Spoken Without a Word,* my first book on the genre. Through faithfully reproduced Album block patterns, it strives to convey the style's artistry.

Though just 11 years ago, by a certain measure *Spoken Without a Word* was written in a quite different era. Today, Victorian eclecticism surrounds us: It is revived in clothing, in architecture, in decorative arts, and in interior decor. Victoriana once again abounds in magazines, gift volumes, and all manner of paper ephemera. With it has come, inevitably, more familiarity with that era's sensibilities, its loyal fellowships, and its overt spirituality. In 1983, no miniature reprints of the *Language of Flowers* decorated bookstore shelves as they do now, and few of us even remembered this symbolic tongue's existence. Thus when, in that first book, I suggested that the Baltimore Album Quilts used an iconography, a symbolic language, I was most tentative. I simply included a lexicon of symbols and the

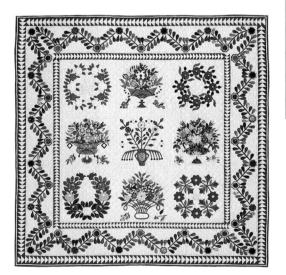

AUTHOR'S
UNDERLININGS &
MARGINALIA

Metamorphosis, or symbol-formation; the origin of human culture. A laurel branch in the hand, a laurel wreath on the house, a laurel crown on the head; to purify and celebrate. Apollo after slaying the old dragon, or Roman legions entering the city in triumph. Like in the Feast of Tabernacles; or Palm Sunday. The decoration, the mere display is poetry: making this thing other. A double nature.
—Norman O. Brown, "Daphne, or Metamorphosis" (Joseph Campbell, Editor, *Myths, Dreams, and Religion*)

AUTHOR'S NOTE

Beautiful! All the laurel wreaths, then and now—in Album quilts!

108. Baltimore Beauties for Bob by Ruth H. Meyers of Dhahran, Saudi Arabia. 1993. 61" x 61".

AUTHOR'S UNDERLININGS & MARGINALIA

The sanctification of the local landscape is a fundamental function of mythology.
—Joseph Campbell with Bill Moyers, *The Power of Myth*

AUTHOR'S NOTE

We also feel a part of the natural world....

113. FAMILY ALBUM by Patricia E. Nigl of Oshkosh, Wisconsin. 1989-1993. 82" x 96".

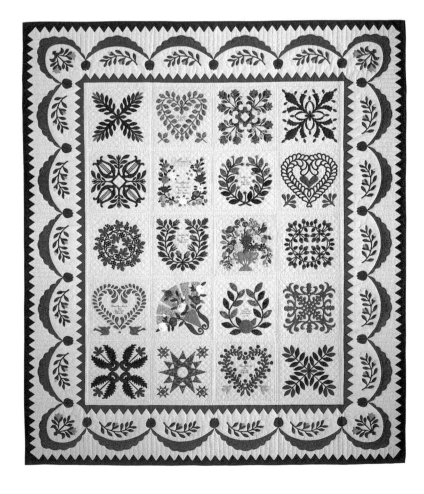

suggestion that these often ancient symbols spoke intentionally of specific lives and times.

Tested now, for more than a decade, the theory that these quilts spoke without words, seems proven true. Moreover, we've deciphered key emblems of whole "world views" through quilt-borne symbols of Baltimore's fraternal orders. The Odd Fellows' symbols and—having officially originated in Baltimore in 1851—those of their women's degree, the Rebekahs, are particularly vividly displayed in the classic Albums. Then, too, we've sensed history's pageantry in these quilts through military insignia and memorials, through flag-borne stars marking the entry of new states into the union, and through the logos of such social movements as temperance and abolition. Thus, to one who listens, the symbols in the antique Albums can carry you well beyond the individual's experience, and when they reflect what is most deeply felt they reach that which is universal.

Makers of the classic Albums used old, even ancient, archetypes and symbols. Borrowing them to inform their own experience, they made the old at once both old and new. Generations later, repeating this quiltmaking ritual, contemporary Album Quilt-makers stitch the same symbols once again. Thus the old is reborn into a new system of symbols related to the present and to each quiltmaker's particular history. Some turn-of-the-20th-century quiltmakers seem uniquely attuned to antiquarian symbolism, reporting that they like not only the Baltimore Albums' objective designs, but also the subjective feelings those quilts convey. Commonly this recogniton is phrased modestly, almost shyly: "I like what the quilts say" is how it's most often put, with no elaboration. But once, after a class, a conversation among a couple of Album makers summed up these feelings:

I like the message in the Albums. I like the gentleness with which it is delivered. ...So much that we hold passionately private, is put publicly in our faces today, whether it be cherished religious beliefs or the intimacy of sexual bonds. It makes precious things ordinary, vulgar. One thing I love about the Albums is the delicacy of their expression. There is an air of restraint, even in their overabundance.

All contemporary Album makers seem to impute some personal meaning to the patterns they choose to stitch and to the very making of their Albums. Almost uniformly, they report that making their Albums gave them pleasure, that "It was a happy time for me." Several have spoken, though, of overwhelming loss, of the death of a child or of a spouse, of stitching their way through an Album to mend the hole in their life's fabric. "And I began to heal," one summed up simply. "It worked. It pulled me back." Though I have since gone on to write much more about the Baltimore Albums, those two threads—the artistic and the symbolic—which first I picked up in *Spoken Without a Word,* still entwine brightly for me, making Album Quilts the stuff of myth and dreams.

With such enthusiastic endorsements, perhaps we should take a closer look at what

might be making Album Quilt-makers so happy. Beyond a doubt, the happiness of making even the simplest Album stems in part from the habitual and joyful affirmation of beauty in everyday life. The Album mode encourages this. With flowers as the Album's common tongue, how could it not be so? Even tragedy recorded in an Album has been integrated with the peace of acceptance and the beauty of understanding. I sometimes picture the Album maker as an olden-day lady taking the air along muddy, malodorous city streets. Rather than succumb to depressive unpleasantness, we're told that the wise mistress would hold fragrant posies called "tussy-mussies" high, so that their sweet floral scents would obscure the stink around her. Even the simplest Baltimore-style Album, antique or revivalist, is garlanded with nature's fragrant bounty. Like counting one's blessings, choosing blocks for an Album Quilt can only cheer and uplift one. Such PollyAnna-ish optimism may not be politically correct, but the sweet sensation is so pleasurable as to be habit-forming!

Album Quilt-makers seem increasingly to see themselves as a fellowship or even a family. This is not surprising since some now call quiltmaking a "subculture," noting that by the following traits, it qualifies. Quiltmaking has: 1. its own charismatic leaders (teachers, authors, books, magazines, publishers, and conference impressarios); 2. its own annual visits to favorite watering holes (as well as guilds, meetings, and "bees"); 3. its own unique regalia; and 4. its own rites like challenges and making raffle quilts. Album Quilt-makers, themselves, seem recently to feel united in an identifiable quiltmaker sub-group—one with their own teachers, books, pins, tote bags, block carriers, fabrics, shows, and, now, a contest! When I teach an Album class these days, whether here or abroad, the people who attend seem to have a cohesiveness, a self-confidence; they seem quite certain that though among strangers, they are yet among friends and right where they belong. Some say they feel they know me from my books, and I feel I know something important about them. With increasing frequency, individuals come back repeatedly for more classes, and

may promise, "You'll see me again." And surely this sense of belonging, of being as with those-who-travel-together, of sharing values, of having common goals is something we all hunger for in our society's explosive numbers and dizzying rates of change.

Pop-psychology, too, offers, in the term "flow," an explanation for why Album Quilt-makers find the experience so compelling, so fulfilling, and so downright exhilarating. When once I asked a quilt class why the needleart of the Baltimore Albums so enthralled us, the consensus answer was, "It's a recognition of excellence." In fact that recognition actually defines a classic style, a style that sets a standard for all time. The artistic heights of the old Maryland Albums have been broadly acknowledged by both the quilt world and the art and antique world. Back in 1983 I had held a block contest based on the patterns in *Spoken Without a Word*. I wanted to test whether numbers of 20th-century women could once again create in the fine-scale appliqué of the classic Albums. Frankly, I wasn't sure we could. For, by the mid-1980s, only a handful of modern quiltmakers had made Revivalist Baltimore Albums. Among the earliest to receive public acclaim were Bernice Enyeart of Indiana and Pat Cox of Minnesota, while Nancy Pearson of Illinois interpreted appliquéd Albums in delightfully original floral appliqués.

That initial contest's seven winners became the first needleartists for *Baltimore Beauties*. By 1984, I myself had begun intensively to appliqué, researching the needleart as well as writing on the history of these quilts. But like the seamless emergence of a bud into full bloom, my "Baltimore" classes by 1986 were increasingly in demand. *Lady's Circle Patchwork Quilts'* Editor, Carter Houck, had even titled the moment, calling the period one of "Baltimore Album Revival." In 1988, C&T agreed to publish *Baltimore Beauties and Beyond, Volume I,* and by 1989 we had the first national show of Revivalist Baltimore Albums in Archbold, Ohio. Sauder Farm and Craft Village sponsored the show for which I'd obtained just half a dozen or so Albums, three of them group-made. But that small exhibition was packed daily by crowds who lingered

AUTHOR'S
UNDERLININGS &
MARGINALIA

*The Indian boy was
saying there is a
shining point where
all lines intersect.
...God is an intelli-
gible sphere—a sphere
known to the mind,
not to the senses—
whose center is every-
where and whose
circumference is
nowhere.*

—Joseph Campbell
with Bill Moyers,
The Power of Myth

AUTHOR'S NOTE

Like the "All-Seeing
Eye of God" icon on
so many old Baltimore
Album Quilts. Like the
All-Seeing Eye of God
in my purse—atop
every dollar bill's pyra-
mid! Is this part of why
we love the Albums
so? They bring back
ancient symbols, help
us hear forgotten
metaphors, help us
understand our place
in the universe?

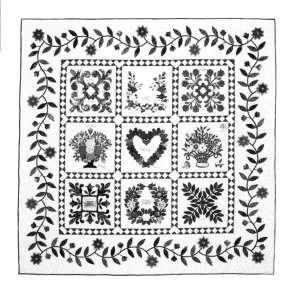

134. MINNESOTA FAMILY
ALBUM QUILT by
Lucy K. Brown of
Rochester, Minnesota.
1991–1993. 69" x 69".

long, seemingly enraptured. Once again, a century and a half later, Baltimore's contagion had begun. Watching the watchers, I could almost sense in the air their growing urge to test their skills, to go for the "peak quilting experience."

"Optimal experience," University of Chicago professor, Mihaly Csikszentmihalyi, tells us, occurs when we're engrossed in a mental or physical challenge. In his book, *Flow: The Psychology of Optimal Experience,* he concludes that we're happiest meeting a challenge sufficiently difficult to be stimulating but not so hard that it's beyond our ability to attain.

If we measure the flow theory's checklist against Album Quiltmaking, we learn something. The theory postulates six elements as crucial for "flow" to happen: 1. The task must test our skills. 2. It must focus our complete attention. 3. It must offer us clear, attainable goals. 4. We must be able to lose both ourselves and, 5. Our sense of time while working to meet the challenge. And 6. We must feel totally in command of the present moment. How can these possibly be attained, you might wonder? To create a hand-appliquéd, hand-quilted Album, one has accepted a challenge comparable to a climber taking on Mt. Everest. But the challenge is incremental, the instructions detailed, and the gratification comes in small bites all along the way.

Talk about attainable goals: these Albums where you make one block at a time provide the ultimate in step-by-step feedback. When a quiltmaker begins with *Volume I's* Lesson 1, she sets out to perfect the cut-away appliqué method whose whole short-term goal is to stitch just 2" or so at a time. (Out of such tiny grains of sand are mighty mountains made.) But, you might well ask, how does a person feel when she's worked at her blocks a year and has just two or four or six of them done? The answer is: Proud. Quietly, gently, but indisputably, proud. For this quilt-making genre seems to carry its own philosophy: "The happiness is in the journey, not at the end of the road." There is a wonderful "You can do it" attitude as stitchers encourage each other; and a whole paraphernalia of block carriers, from appliquéd cases to printed pizza boxes, has evolved among Album makers for storing and displaying their squares. By 1991, it crossed my mind that these showpiece blocks, these treasured possessions, had begun to take on a life of their own, somewhat like purchased fabric too beautiful to cut into. Along with pride, one could feel a certain contentment of accomplishment settling in: With such a prettily packaged and so much admired Album block collection who, really, was anxious to finish her quilt? Who wanted to rush and thereby, perhaps end this pleasant journey?

Into this peaceful scene, C&T dropped their 1994 Baltimore Album Revival Contest. Contests are not everyone's cup of tea. But quilt contests provide miracle-working incentives for some. Thus C&T's contest lit a spark that raised the Album makers' "optimal experience meter" to fever pitch! The aspiration to be Number One, to gain accolades and fame is natural to Man. Historically it has led to great accomplishments. On the other hand, "elitism" is currently disparaged. One hears that among top colleges and universities, the trend is to give everyone a "Gentleman's A" lest professors be forced to make invidious distinctions, or perhaps hurt feelings, or by so doing damage someone's self esteem. But imagine human history without some recognizably best and brightest, or perhaps with no freedom to excel noticeably, or no incentive to strive harder.

Sponsoring a contest invites honorable pride and rewards the desire to stand out. In a quiltmaker these traits can lead to great quilts. Without a doubt, the Maryland Institute exhibitions of the 1840s and 1850s helped spur the original Baltimore Album Quilts on to classic heights. One can almost watch the evolution take place within those quilts as the quiltmakers learned from one another, learned from one year's quilts to the next, and got better. Plato (as translated by Alan Bloom, in his *The Closing of the American Mind*) called such admirable ambition the "search of spiritedness for legitimate self-expression." Thus, once C&T's contest was announced, exhilaration peaked rapidly, then held solidly for almost a year before the October 1993 deadline. When we enter the exhibit hall, you and I may even be able to assess the oceans of "flow" enjoyed, simply by estimating the yards of quilting thread used!

To be fair about it, flow or peak experience can be present throughout all of quiltmaking. But I like to call Album Quilts the "Outward Bound" of quiltmaking. Few quilt styles are richly faceted enough to engross a quiltmaker so completely as do these, and for so long. And few quilt genres are meaty enough to fuel seven books—and counting—from a single pen. The wealth to be had is not just in the technical challenge; it is also in the inward journey the Album maker takes—unfolding her heart and soul through the meditative work of her hands. As though to mark their depth of meaning for us, quiltmaking's phrases have entered the language as powerful figures of speech. Quiltmaking's metaphors, those images that make dissimilar things into a harmonious, even beautiful, whole, ease the quiltmaker's understanding of her life and times.

The Album maker sifts through that which is meaningful enough to record, that which is transient, that which she can hope to change, that which the quiltmaking will help her to accept. To plain, utilitarian cloth we stitch decorative beauty, where another might not have. The stuff of making Album blocks, this stitching of icons and abundance, unlocks our powers of memory and imagination. We find some continuity, some universals in the old emblem's meanings while some we imbue with secrets of our own. Continuity and contradiction. Our life is like an Album—much of it a given, but many of the steps along the way are taken by choice. We hope our Album will find favor, tie us to each other, speak for us still, when we no longer stitch and quilt. And if the quiltmaker's love is the antique Albums, she sews with a sense of history that aids her perception of what she's come from, who she is, and where she's going.

It's almost time for the Baltimore Revival Exhibit to open its doors. What you see will, I think, please and impress you. You will see quilts made singly and in groups, by women whom you probably do not yet know. Some of the quilts will sing in a loud clear voice with a song meant for you to hear. Some sing more softly, almost to themselves. Like my first visit with the old ones, you, too, may sense that these quilts are speaking to you without words, in the symbolic mode. But it

409. MY FAVORITE BALTIMORE BEAUTIES by Karen Larsen-Bray of Walnut Creek, California. 1993. 60½" x 60½".

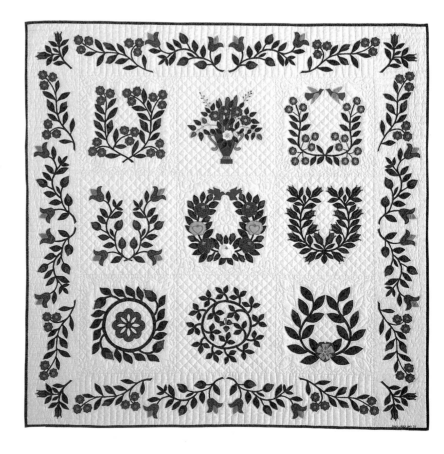

AUTHOR'S
UNDERLININGS &
MARGINALIA

The phrase "creative person" is one who is able to draw upon the images within himself and then to embody them in outer works, moving inward again and again for the in-spiration of new source material, and outward again and again to learn from his artwork what it wants to become while he is working on it.
—Ira Progoff,
Waking Dream and Living Myth

AUTHOR'S NOTE

Album makers say, "Commit to one choice at a time. Let the quilt 'talk to you,' saying what comes next."

430. A PEACOCK IN THE GARDEN by Patricia Brundage of San Manuel, Arizona. 1993. 87" x 99".

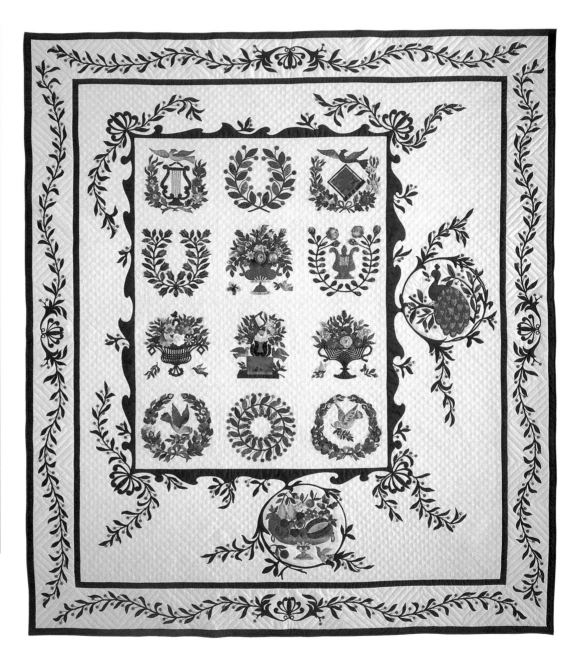

would take a long visit to hear what some Albums would say when you knew them better. In the exhibition hall, the essay submitted with each quilt has been hung behind the quilt in a plastic sleeve. I hope you'll get the chance to read a bit of what each quilt-maker shares there, as well.

Their bright colors and full-bloomed beauty drew me to the Baltimores 12 years ago. And their symbolism has held me since, as though it nourished me with something

long hungered for. The psychologist Carl Jung wrote that we have suffered "an un-precedented impoverishment of symbols." To have seen the Gulf War's yellow ribbons waving across the land, it seems that this is so. We are a people longing for common ground, seeking a way to unite, and we seem unable to do it through words. Words set us to arguing, magnify our differences. Symbols, because they speak without words, speak directly to our hearts.

It would not overstate the case to say that Baltimore-style Album Quilts obsess me. It is as though, for me, Album Quilts have become the myth, the imagery, by which I make sense out of much of life. Of all curious topics to send me back to the Albums for answers, a recent trip to Manhattan caught me engrossed by territorial turf fighting, street gangs, and their symbols. Our nation's capitol is my hometown. When I travel to lecture I'm repeatedly asked, "Do you actually live right *in* Washington, D.C.?" And to that question which conveys incredulity, I answer "Yes, right in the city." As you know it is among the world's most beautiful burghs, but as lengendary now for its crime as for its culture.

Last Spring though, I was as wide-eyed as a country girl when in New York City for the Great American Quilt Festival. As in an echo, I heard myself asking members of the Manhattan Quilter's Guild, "Do you really live right *in* New York City?" Then, when my colleague pointed out that the ornate graffitti we passed each day were gang symbols marking territory, I got so excited: Brotherhoods, icons, secrets—stuff of the Album Quilts! One elaborate, quite lovely symbol had been sprayed in metallic gold paint through a cut stencil. That motif, like the young men who served us in that district's street markets, looked Middle Eastern. Later, in the mail, the same quiltmaker friend sent me a promised flyer of further gangland information from the U.S. Marshall's Office. The pamphlet explained how a symbol crossed out or drawn on top of, witnessed a territorial takeover. It noted that gangs wore special "colors" or identifiable regalia, and explained that secret handsigns were signals, signs of recognition between "brothers."

And I thought of the myth, and of the Album Quilts, of the fraternal order handsigns, of how even the Boy Scout Handshake must be connected to this need for acknowledging a brother, for identifying with one's own. I thought of how excited the women must have been when, in 1851, the Brotherhood officially recognized a Sisterhood—the Rebekahs. Now <u>that</u> coming was something

to stitch into life's Album! And I pondered modern quiltmaking, all of us ladies and a few men, as itself a subculture. April a year ago, right there in front of the Museum of American Folk Art on West 62nd Street, two polarities—the quiltmakers and urban gang members—touched. Each informed the other. That moment when they touched floodlit something I'd not seen before. Through antique Baltimore's myth, I understood something about our common humanity: ours and that of our needlesisters of yore; ours and that of the youthful street gangs. Through the Album metaphor, I realized how we all need so to belong. I thought I'd spotted another common thread. [Might I tonight be mischievously uncool? Might I share from this public podium the suspicion that I may be an uninitiated member of the "Album Gang"? This sense of belonging feels good. And hey! Album makers are my kind of people!]

I've confessed to you that these are Album-colored glasses through which I see the world, so it should not surprise you that I found quilts in an essay by Jodi Daynard from *The New York Times Book Review* of March 28, 1993. It was titled "Floppy Discs are Only Knowledge, But Manuscripts are Wisdom." Like so much that I read these days, this piece on manuscripts became a metaphor for me about Album Quilts. Ms. Daynard expressed herself so beautifully that I'd like to conclude tonight's address by paraphrasing one of her

AUTHOR'S UNDERLININGS & MARGINALIA

Whatever the reasons that a person embarks on the continuous communication between the inner and outer worlds, whether because of a compulsion or because of a calling, it seems that if he remains committed to the dialectical process something new and unexpected emerges in his life. It is as though the core of a center forms within him. A new self forms, not from his directly seeking it, but as a side effect of the integrity with which he continues his inner-outer journey.
—Ira Progoff, *Waking Dream and Living Myth*

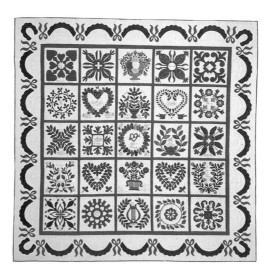

717. MY BALTIMORE ALBUM QUILT by Avis Annis Spicer of Rutland Town, Vermont. 1989-1993. 92" x 92".

AUTHOR'S
UNDERLININGS &
MARGINALIA

Institutions like this operate in two ways. While they improve art, they improve the artizan[sic]. While they facilitate and perfect the labor of the hands, they call into action, rouse up and make active, the labor of the brain. And this last is truly their noblest function. The work of the hands ... has the common fate of all human creations: but thought is imperishable, and once developed, expressed and illustrated, lives forever.
—John H. B. Latrobe, Esq., "Annual Address before the Maryland Institute for the Promotion of the Mechanic Arts, Delivered at its First Annual Exhibition, Opened at Washington Hall Building, Baltimore, October, 1848."

paragraphs, rewriting it as though it spoke not of manuscripts, but of quilts:

In many ways quilts are the most fragile and humble of human products. More often than not a quilt records but a tiny vicissitude of time, one soul stitching across the mental rapids from one stone to another, in the eternal hope of getting somewhere. And yet, looking at a quilt, one sees a wholeness; one feels—if only momentarily—wise. Perhaps this is because the true beauty of a quilt lies not so much in what it reveals as what it hides. Quilts, like other art, contain a powerful core of mystery. How is it, after all, that I can study a vintage Baltimore Album Quilt and, by dint of smell, almost feel the maker's presence as surely as the blind feel a tree before they touch it? Somewhere in this mystery lies the mystery of our connectedness to others. Not literally—in the sense of shared conversations or relatives nor even of shared theologies, but spiritually, as in a shared understanding: An understanding that cloth shreds, threads break; that the fine stitches of our young and middle years inevitably yield to the stiffened hands of old age. Soon, very soon, quilts seem to tell us, we will be nothing more than the fine-stitched—or simply basted—blocks we leave behind.

But though just threads, these quilts are the thread of a life here on earth, a life amidst the living, a thread stitching us through to those who have come before and to those who will come after. We have gathered here to celebrate both the quilts of antebellum Baltimore and those beautiful Baltimore-style Albums, which surround us here. Stitch by stitch, stepping stone by stepping stone, our contemporaries have taken this quilt style, this mystery, so beautifully beyond Baltimore and out into the rapids of our modern lives. Out of the mystery of those antique quilts we come, and into it we return.

Traditionally, we quiltmakers have stitched our noblest souls, our loftiest commitments into our Albums. Let us believe that a nobly wrought quilt increases the moral wealth of man and enriches the future. "Human destiny," Rev. Robert Cope wrote, in my father's memorial service, "is a great one because the essence of it is tragic. All that we build crumbles. All that we embody turns to dust. All that we love we must one day leave behind us. That which alone endures is the spirit in which we understand and meet our fate. This we pass on to our children, our comrades, our friends. Only a breath indeed, but the breath of life." And for a quiltmaker her testament is tangible. She threads the fabric of her life through with a noble acceptance and love. And she is reassured to know that her quilts are like old friends: They connect her to the past, they give happiness and stability to her present, and through this, her Friendship's Offering, they tie her to the future.

Will the beauty of these quilts on exhibit lie as much in what they hide as what they reveal? Let's braid our three-ply cord of judgment over that one as we proceed now, on to the show.

THANK YOU. AND ENJOY!

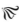

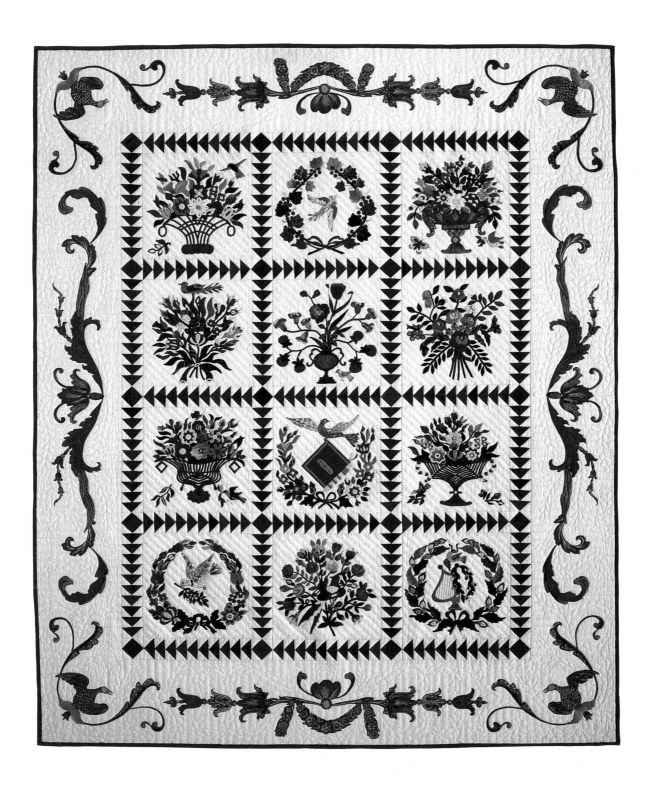

102. Baltimore Style
LaDonna Christensen
Los Osos, California, 1991–1993
67" x 81"

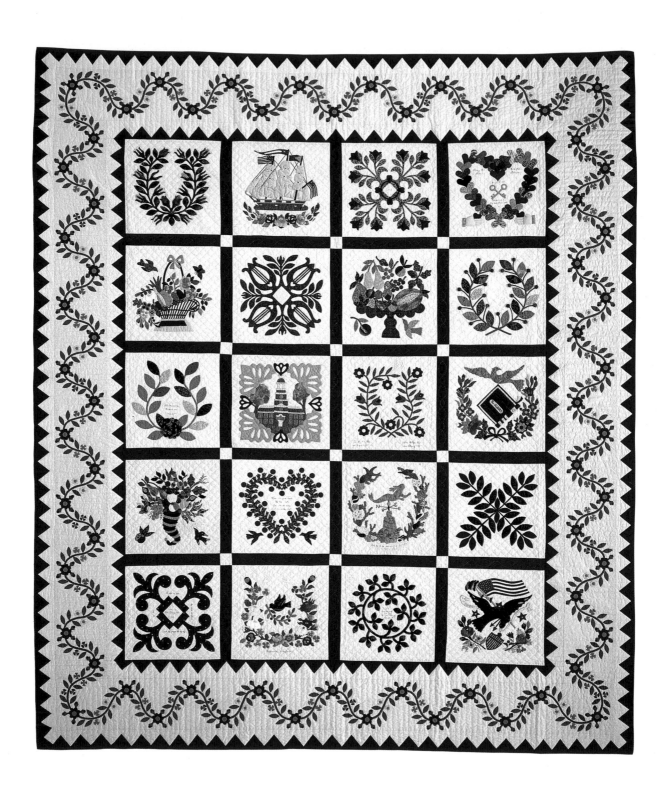

103. BETH'S TRIP TO BALTIMORE
Beth Gillaspy Allen
Perkiomenville, Pennsylvania, 1992–1993
84½" x 100½"

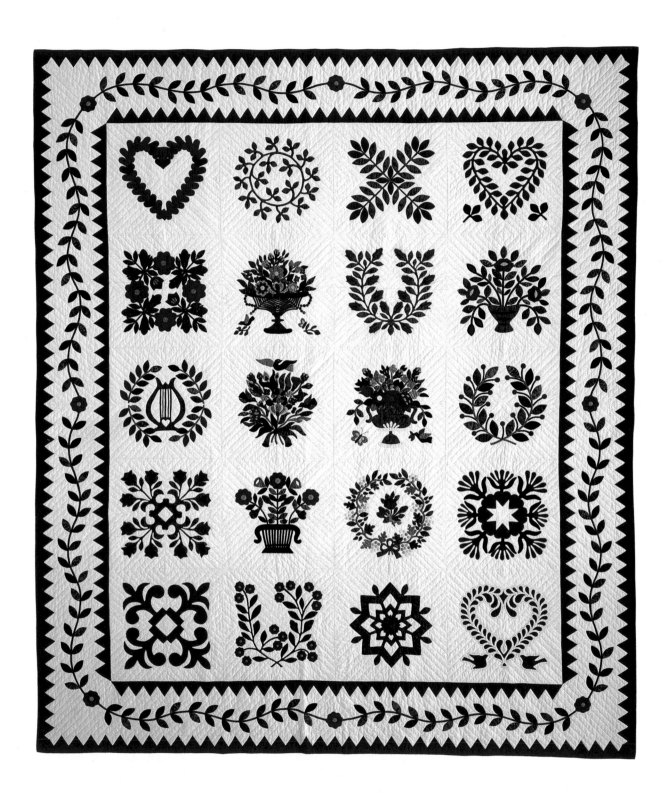

110. BALTIMORE ALBUM
Phyllis Norton
Tolono, Illinois, 1992–1993
81" x 94"

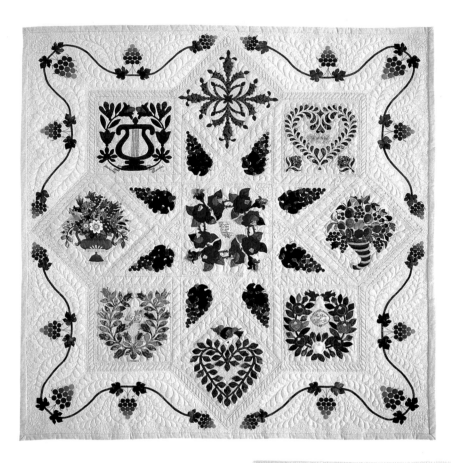

123. WHERE YOU TEND
A ROSE
Lisa D. McCulley
Patuxent River, Maryland, 1993
68" x 68"

128. BEAUTIFULLY BALTIMORE
Dale B. Schofield
Ossipee, New Hampshire, 1993
65" x 64"

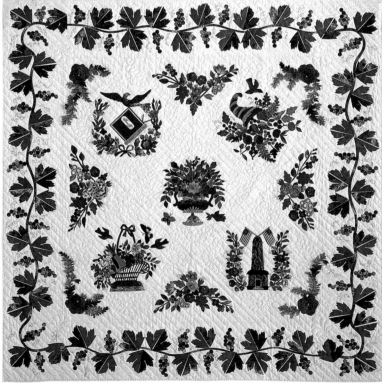

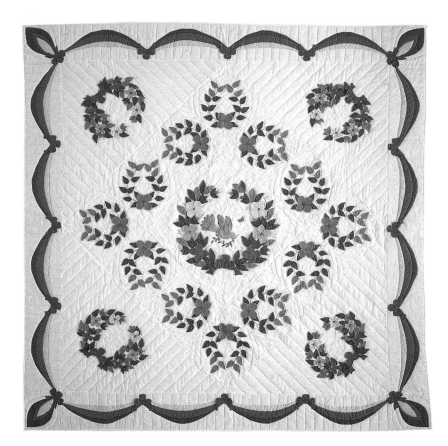

407. BUTTERFLIES BEYOND
BALTIMORE
Sandy L. Broering
Rising Sun, Indiana, 1993
92" x 92"

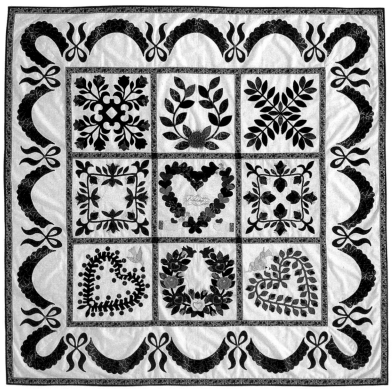

139. MY HEART OF HEARTS
Lisa Schiller
Houston, Texas, 1991 to 1993
61" x 61"

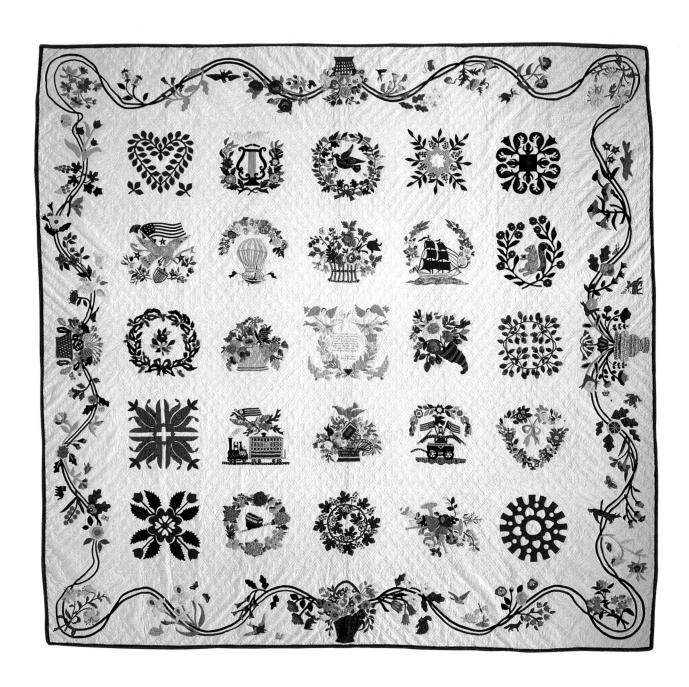

119. SIX IMPOSSIBLE THINGS BEFORE BREAKFAST
Joanne N. Frey
Pittsburgh, Pennsylvania, 1989-1993
110" X 110"

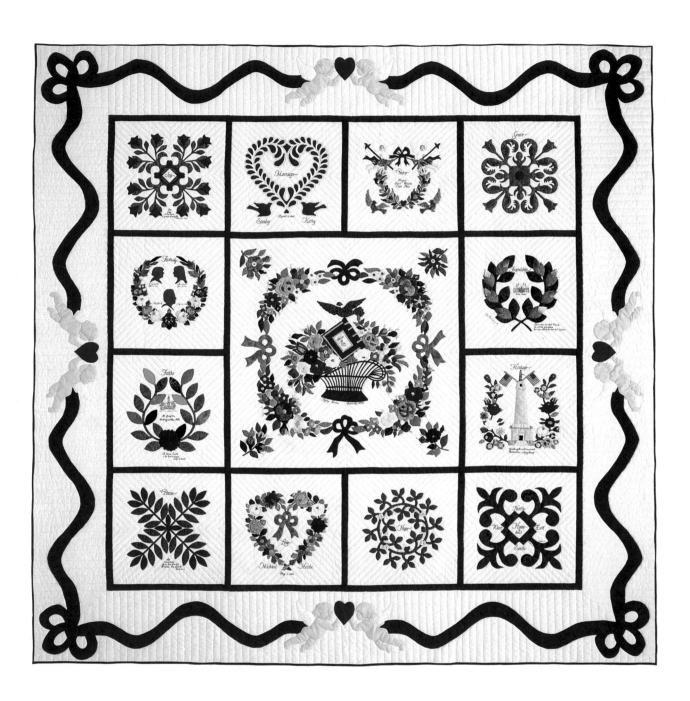

121. WORDS OF LIFE
Kathy Siuta
Cockeysville, Maryland, 1991–1993
87" x 87"

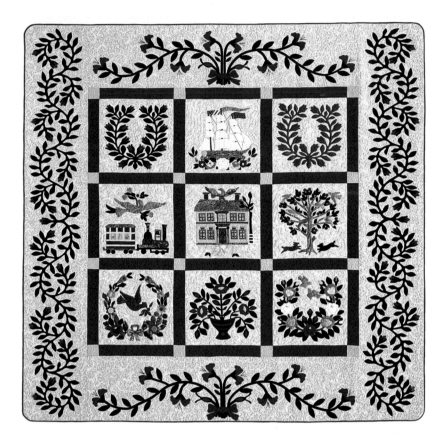

414. Baltimore Avec
la Machine à Coudre
Patricia L. Styring
St. Augustine, Florida, 1993
68" x 68"

420. The Progressive Album
Betty Alderman
Mansfield, Ohio, 1989–1993
65½" x 65½"

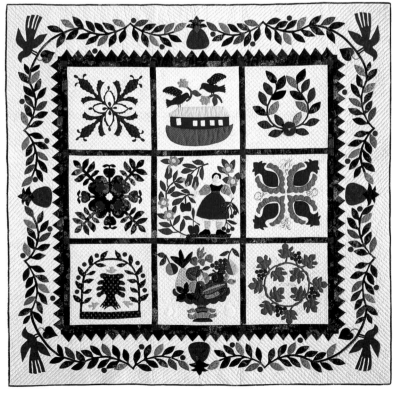

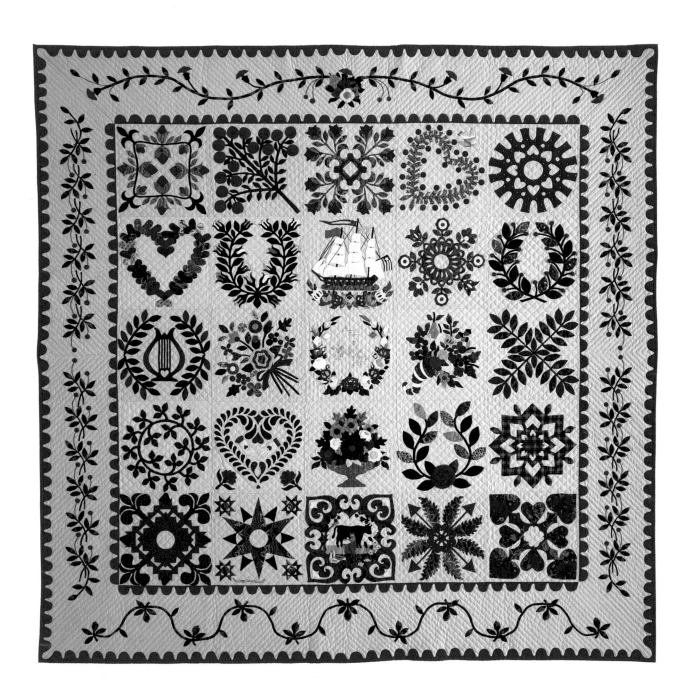

132. BALTIMORE LEGACY
Carol Latimer
Weatherford, Texas, 1989–1992
83" x 83"

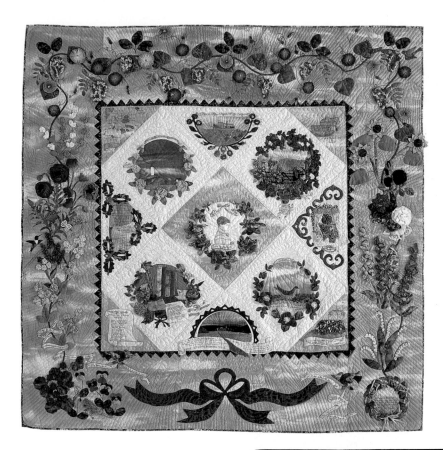

727. A Tribute to
Celia Thaxter (1835-1894)
Faye Samaras Labanaris
Dover, New Hampshire, 1993
68" x 68"
*Detail of this quilt
is on the cover.*

441. Baltimore? Texas, U.S.A.
Lisa Schiller
Houston, Texas, 1991 to 1993
62" x 62"

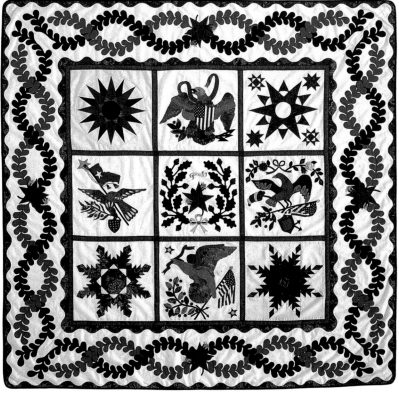

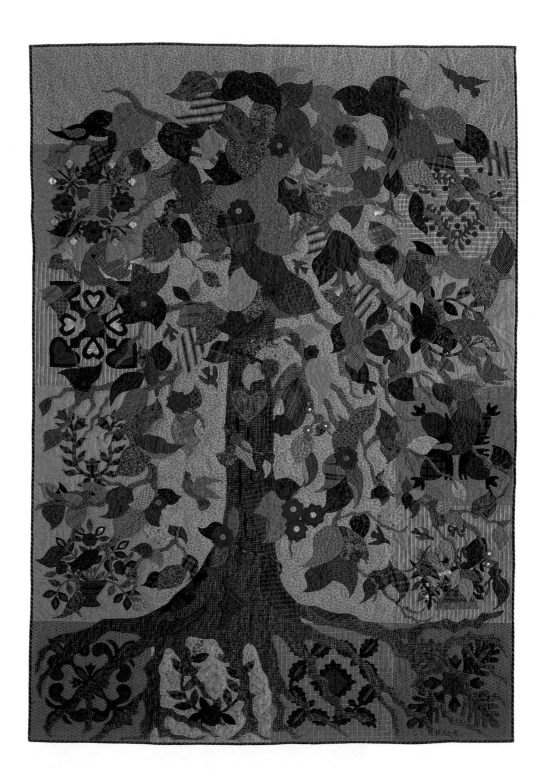

432. A Tree Grows in Baltimore
Madonna Auxier Ferguson
East Lansing, Michigan, 1992–1993
63" x 92"

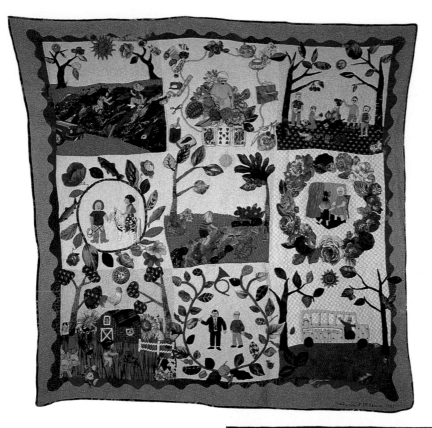

730. KINNIKINNICK CREEK
ALBUM
Katherine L. McKearn
Towson, Maryland, 1993
59" x 63"

734. [HERE'S TO YOU, ELLY—]
THIS BUD'S FOR YOU
Patricia A. Timms
Rochester, Minnesota, 1991
80" x 80"

434. BALTIMORE COUNTY ALBUM QUILT
Katherine L. McKearn
Towson, Maryland, 1991
69" x 69"

436. To Baltimore, My Way
Sylvia Gentry Richardson
Marion, Virginia, 1993
72" x 72"

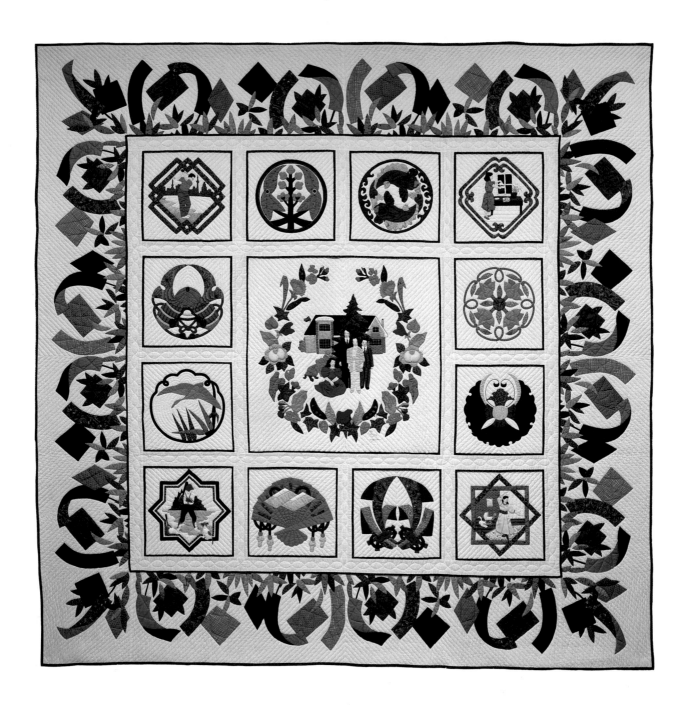

700. The Tanaka Family Album Quilt
Cindy Notarianni Swainson
Scarborough, Ontario, Canada, 1991–1992
81½" x 81½"

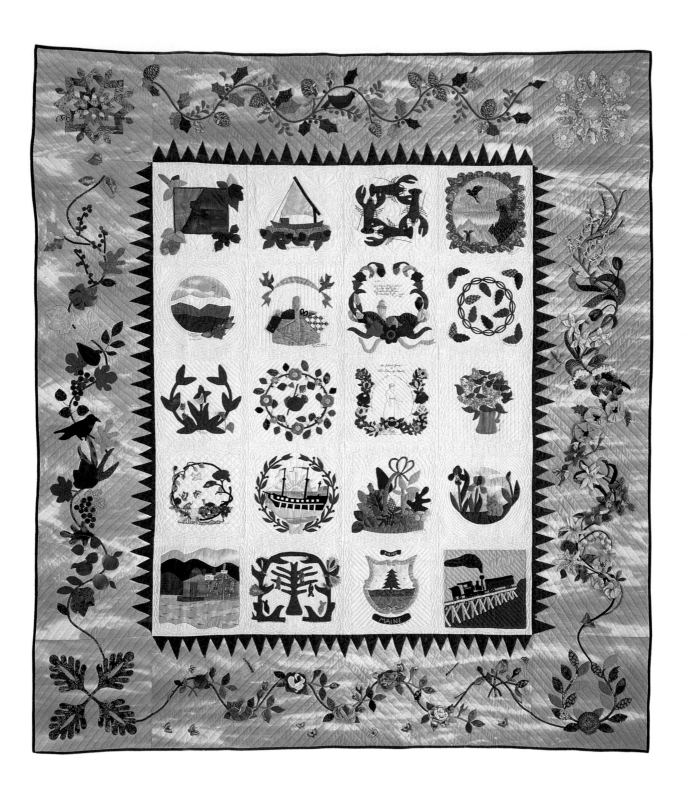

439. A NEW ENGLAND ALBUM QUILT
The Good Ladies of Baltimore North and
The Cocheco Quilters Guild of Dover, New Hampshire, 1991–1993
87½" x 97"

The Baltimore Beauties Series Quilts

Needleartists from across the country have graced the *Baltimore Beauties* series with blocks that illustrate each book's patterns and techniques. Many of these blocks travel extensively, carried in portfolios to be shared in Album Quilt classes around the world. But over the years, several quilts have also been completed using many of the needleartist blocks in combination with ones that I have made. Both gifts of appliqué and commissions from professional quiltmakers have finished these quilts. For the first time, several of these *Baltimore Beauties* series quilts (including some made entirely by, and belonging to friends and neighbors) are shown together here at the Baltimore Revival Exhibition:

1. THE GOOD LADIES OF BALTIMORE.
Group Quilt.
1984-1988.
Border appliquéd by Agnes Cook; quilting by Virginia Lemasters and Carol Jo White. This quilt and its needleartists' biographies are published in *Volume I*. Fifteen of the blocks resulted from the 1984 contest inspired by the publication of *Spoken Without a Word*. Elly Sienkiewicz made the other ten blocks, designed and set the quilt as a Bride's Quilt for her daughter, Katya, just ten years old when the quilt was finished.
91" x 91".

2. THE FASCINATING LADIES OF BYGONE BALTIMORE.
Group Quilt.
1984-1988.
The border was appliquéd by Zollalee Gaylor, the center medallion by Kathy Pease. Five blocks are from the *Spoken Without a Word* Contest; seven blocks are by Elly Sienkiewicz who designed and set the quilt as a future Groom's Quilt for her son Donald, then seventeen. Its "album of quilting patterns" was designed and sewn by Hazel B. Reed Ferrell. This quilt and its needleartists' biographies are published in *Volume I*.
79" x 79".

3. FRIENDSHIP'S OFFERING.
Group Quilt.
1988.
This quilt was made for Mary Sue Hannan under the direction of Kate Fowle and Elly Sienkiewicz. Center medallion appliquéd by Kate Fowle; quilted by Emma and Fannie Hershberger. Though its colors differ, this quilt is quite close in aspect to the 1847 Pennsylvania quilt made by Sarah Holcombe, which inspired it. As in that quilt, the majority of the blocks are paper-cut ones, done by the cut-away appliqué method. This quilt and the list of friends who made it for Mary Sue Thomas Hannan's 70th birthday are published in *Volume I*.
115" x 115"

4. MORE MARYLAND FLOWERS.
Group Quilt.
1984-1990.
Designed and four blocks made by Elly Sienkiewicz. Border appliqué by Susan Alice Yanuz, its "album of quilting patterns" was designed and sewn by Susan Runge. This quilt and its needleartists' biographies are published in *Volume II*. A wide cut-away appliqué border (Pattern #21 in *Volume II*) gives a bright, opulent look to this nine-block Album. Despite its small number of 12½" blocks, this quilt covers the top of a queen size bed nicely with the addition of pillow shams.
66" x 66".

5. ODENSE ALBUM.
Group Quilt.
1989-1990.
Quilt and border design, two blocks and the inkwork done by Elly Sienkiewicz. Border appliquéd by Albertine Veenstra. Audrey Waite made the sashings using a Trudie Hughes method, and set the quilt together. This quilt and its needleartists' biographies are published in *Volume II*. Invited to teach at Quilt Expo Europa '90 in Odense, Denmark, the author designed this quilt in honor of Hans Christian Andersen, Odense's Victorian-era native son. He was a papercutter as well as a writer, and each row's center block features one of his papercuts. His Little Mermaid is inked to the

right of the center block, and a statue honoring him in Central Park, to the left.
70" x 70".

6. CLASSIC REVIVAL ALBUM.
Author-designed Group Quilt.
1986-1991.
This quilt and its needleartists' biographies are published in *Volume III*. A small picture of it accompanies its border pattern in *Appliqué 12 Borders and Medallions! A Pattern Companion to Volume III of Baltimore Beauties and Beyond, Studies in Classic Album Quilt Appliqué*.
96" x 96".

7. ALBUM IN HONOR OF MOTHER.
Author-designed Group Quilt.
1984-1993.
This top is published in *Volume III*. A small picture of it (and the needleartists' biographies for Barbara Hahl and Yolanda Tovar who made the central medallion) accompanies its border and center medallion pattern in *Appliqué 12 Borders and Medallions! A Pattern Companion to Volume III of Baltimore Beauties and Beyond, Studies in Classic Album Quilt Appliqué*. Sylvia Pickell and Ruth Meyers appliquéd the borders. Ruth set and bound the top. A glorious top, yet to be quilted, Album in Honor of Mother houses blocks from *Dimensional Appliqué*. One red vase block (D-3) was machine appliquéd by Annie Tuley, using Renaissance wool, while half a dozen other blocks were exquisitely embroidered by hand. Yolanda Tovar executed the masterful gold couching on the Album.
81" x 81".

8. HEART-GARLANDED ALBUM MINIATURE.
Rhondi Hindman.
1992.
Made by combining fused appliqué and machine quilting. This quilt, all the patterns for it as well as its full-sized version, and its needleartist's biography are published in *Design a Baltimore Album Quilt, A Design Companion to Volume II of Baltimore Beauties and Beyond, Studies in Classic Album Quilt Appliqué*.
40" x 40".

9. HEART-GARLANDED ALBUM.
Group Quilt.
1992-1993.
Border machine appliquéd by Annie Tuley, quilt set together and hand-quilted by Genevieve A. Greco who also designed the quilting. This quilt and its needleartists' biographies are published in *Volume III*. This quilt both celebrates the fact that the pattern for an entire reproduction classic Baltimore Album Quilt is included between the covers of *Design a Baltimore Album Quilt* and gives the original well-worn quilt new life. In addition some of its block designs, beautifully rendered by needleartists whose biographies are in *Volume III*, travel in the *Baltimore Beauties* block model portfolios.
82" x 82".

10. THE NEEDLEARTIST'S ALBUM.
Author-designed Group Quilt.
1985-1992.
The folded rose border and dimensional floral center medallion were appliquéd by Joy Nichols, while the quilting was done by Joyce Hill. This quilt and its needleartists' biographies are published in *Volume III*. A small picture of it accompanies its border and center medallion patterns in *Appliqué 12 Borders and Medallions! A Pattern Companion to Volume III of Baltimore Beauties and Beyond, Studies in Classic Album Quilt Appliqué.*
68" x 81".

11. BALTIMORE BEAUTIES ALBUM.
Author-designed Group Quilt.
1984-1993.
This quilt and those of its needleartists' biographies still to appear in the series are published in *Volume III*. A small picture of it accompanies its border pattern in *Appliqué 12 Borders and Medallions! A Pattern Companion to Volume III of Baltimore Beauties and Beyond, Studies in Classic Album Quilt Appliqué.*
97" x 97".

12. BONNIE'S ALBUM.
Kathryn Blomgren Campbell.
1988-1989.
Designed and made for Kathie's daughter, Bonnie Elizabeth. This quilt, its bor-

der pattern, and Kathie's needleartist biography are in *Appliqué 12 Borders and Medallions!* Bonnie's Album is also pictured in *Volume III* where many of its block patterns appear.
86" x 103".

13. LINDSAY'S ALBUM.
Kathryn Blomgren Campbell.
1988-1989.
Designed and made for Kathie's daughter, Lindsay Kathryn. This quilt, its border pattern, and Kathie's needleartist biography are in *Appliqué 12 Borders and Medallions!* Lindsay's Album is also published in *Volume III* where many of its block patterns appear.
95" x 95".

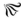

The Contest Quilts

CATEGORY NO. I.:
REVIVAL OF A CLASSIC STYLE
(sponsored by P & B Textiles, Inc.)

100. BALTIMORE WITH A TOUCH OF GEORGIA.
Mary Sue Layton.
Georgetown, Delaware.
1989 to February 1992.
Twenty-five traditional hand-appliquéd blocks set with red sashing and a red and green Hammock and Bow border edged with red Dogtooth triangle borders on both sides. Primarily 100%-cotton fabrics along with some silk and metallic fabric. One inscription, the word "Love" in the reverse-appliquéd Heart block. Hand-quilted.
90" x 90".
Made for the maker.

101. LABOR OF LOVE.
Charlene Karnes.
Salina, Kansas.
January 1991 to April 1993.
Sixteen traditional hand-appliquéd blocks set together with green sashing and surrounded by a 10" green and red Laurel Leaf border. 100%-cotton fabrics. Hand-quilted.
85" x 85½".

Made for the maker's husband, Gerald Karnes.

102. BALTIMORE STYLE.
LaDonna Christensen.
Los Osos, California.
1991 to 1993.
A very classical format with 12 hand-appliquéd blocks. Red Flying Geese sashing and a *Broderie Perse* border made from a French restoration fabric. Birds in each block echo those in the border corners. 100%-cotton fabrics. Hand-quilted.
67" x 81".
Made for the maker.

103. BETH'S TRIP TO BALTIMORE.
Beth Gillaspy Allen.
Perkiomenville, Pennsylvania.
January 1992 to June 1993.
Twenty hand-appliquéd and hand-embroidered blocks with red sashing, a Flowering Vine border edged with red Dogtooth triangle borders on both sides. Maker designed the Independence Hall and Mermaid Weathervane Lyre blocks as well as the border. 100%-cotton fabrics and thread as well as gold metallic thread. Inscriptions in brown Micron Pigma pen. Hand-quilted.
84½" x 100½".
Made for the maker and her husband.

104. DREAMS OF BALTIMORE.
Kathleen Kuiper.
Holland, Michigan.
December 1990 to 1992.
Sixteen traditional hand-appliquéd blocks with pastel backgrounds. The four center blocks form a Peony Medallion. Green print sashing and a Swag and Tassel border edged with a Sawtooth triangle border on the inside. Primarily 100%-cotton fabrics. Hand-quilted.
83½" x 83½"
Made for the maker.

105. DREAM, HOPE AND FAITH.
Else Middelthon.
Oslo, Norway.
February to May 1993.
Nine hand-appliquéd blocks predominantly in reds and greens with a 12" red

Peony and Hammock border. 100%-cotton fabrics. Machine-assembled, and hand-quilted.
61" x 61".
Made for the maker.

106. A WINTER'S GARDEN.
Madeline Poster.
West Bloomfield, Michigan.
1992 to 1993.
Twenty-five hand-appliquéd blocks with mostly pink flowers and maroon sashing. White and maroon solid borders. 100%-cotton fabrics, silks, and ruched ribbons. Hand-quilted.
90" x 90".
Made for the maker.

107. BALTIMORE ALBUM.
Rachel E. Rust.
Camano Island, Washington.
January 1990 to April 15, 1993.
Hand-appliquéd multi-colored medallion center with a dark green frame, surrounded by 16 traditional blocks primarily in reds and greens. A green Rose Leaf Vine border with Ruched Roses at the corners was adapted by the maker from the medallion center. 100%-cotton and silk fabrics. Heavily hand-quilted.
104" x 104".
Made for the maker's family.

108. BALTIMORE BEAUTIES FOR BOB.
Ruth H. Meyers.
Dhahran, Saudi Arabia.
January to July 1993.
Nine multi-colored hand-appliquéd blocks with a green appliquéd Angular Rose Vine border edged with red Flying Geese borders on both sides. 1828 German poem inked in top left block. Includes hand-dyed cotton fabrics, Thai silks. Silk thread used for embroidery and cotton quilting thread used for the hand quilting.
61" x 61".
Made for the maker's husband, Bob.

109. BECAUSE I NEVER SENT YOU FLOWERS.
Loraine (Lori) Isenberger.
Crystal Lake, Illinois.
June 1991 to July 1993.
Hand-quilted white center of interlock-ing rings with feathers and a cross-hatch background. Center surrounded by 12 hand-appliquéd blocks in reds, pinks, and greens with a Red Poppy border. Cotton and poly-cotton fabrics.
73" x 73".
Made for the maker's husband, Dick Isenberger.

110. BALTIMORE ALBUM.
Phyllis Norton.
Tolono, Illinois.
August 1992 to June 1993.
Twenty multi-colored hand-appliquéd (with silk thread) blocks surrounded by a green and red Flowering Vine border edged with red Dogtooth triangle borders on both sides. 100%-cotton fabrics, including hand-dyed ones. Hand-quilted.
81" x 94".
Made for the maker.

"Making a quilt is like planting a tree. It is an act of love and of faith in the future."
—Inscription on quilt by Lucy Brown of Rochester, Minnesota.

111. BALTIMORE ALBUM.
Clara Pope.
Syracuse, New York.
January 13, 1990 to April 1991.
Twenty multi-colored needleturn-appliquéd blocks surrounding a Bird, Book, and Basket Medallion center. The blocks are surrounded by a green and red Hammock and Bow border edged with red Dogtooth triangle borders on both sides. 100%-cotton fabrics. Hand-quilted.
84" x 114".
Made for the maker's son, Gary Pope.

112. ALICE AND TOM'S BRIDAL QUILT.
Alice B. Ridges.
Lakewood, Colorado.
1985 to May 1993.
Hand-appliquéd Basket medallion center surrounded by 28 blocks. Green, blue, pink, red, yellow, purple, and orange cotton fabrics (some from Alice Ann's clothes over the years) used in sequence plus satin and lace from the bridal dress that Alice Ann wore in 1988. Hand-quilted.
120" x 120".
Made for the maker's daughter, Alice Ann, and her husband, Tom Henshaw.

113. FAMILY ALBUM.
Patricia E. Nigl.
Oshkosh, Wisconsin.
August 1989 to July 24, 1993.
Twenty multi-colored hand-appliquéd blocks with 1" background sashing and 13" red Swag With Yellow Flower Spray borders edged with a rose Dogtooth triangle border on the inside and a dark green Dogtooth triangle border on the outside. Calligraphy inscriptions. 100%-cotton fabrics. Machine-assembled and hand-quilted.
82" x 96".
Made for the maker and her husband, Thomas Nigl, to celebrate their 25th anniversary.

114. REPRODUCTION OF BALTIMORE BRIDE QUILT.
Nell Sanders.
Pittsfield, Illinois.
Finished March 1993.
Twenty hand-appliquéd blocks with red sashing and a green Swag and Bow border edged with red Dogtooth triangle borders on both sides. Inked inscriptions. 100%-cotton fabrics in turkey red, hunter green, and off-white. Hand-quilted.
92" x 112".
Made for the maker.

115. AMOUR GALORE.
Dianne Miller.
North Attleboro, Massachusetts.
1989 to July 1992.
Nine hand-appliquéd blocks in red and green with a heart theme for family love and friendship. Surrounded by a green and red Triple Swag and Heart border edged with a red Dogtooth triangle border on the inside. Maker designed the middle row righthand block and the border. Hand-quilted.
68" x 68".
Made for the maker's family.

116. BALTIMORE BEAUTIES.
Joan Ancin Rihan.
Dallas, Pennsylvania.
1990 to January 1991.
Twenty-five hand-appliquéd blocks with red sashing and a green and red Hammock and Bow border edged with red Dogtooth triangle borders on both sides. 100%-cotton fabrics. Hand-quilted. 100" x 100".
Made for the maker and her husband.

118. BALTIMORE REVIEW.
Carolyn (Sissy) Anderson.
Lithonia, Georgia.
May 1989 to April 1992.
Twelve multi-colored hand-appliquéd blocks with double chevron quilting and an appliquéd green and red Swag and Bow border with feather quilting. Primarily 100%-cotton fabrics. Signatures of the maker's teachers, Joyce Selin and Elly Sienkiewicz, as well as other inscriptions in each block. Hand-quilted. 70" x 86½".
Made for the maker.

119. SIX IMPOSSIBLE THINGS BEFORE BREAKFAST.
Joanne N. Frey.
Pittsburgh, Pennsylvania.
1989 to 1993.
Twenty-five multi-colored hand-appliquéd blocks surrounded by a Basket and Flowering Vine border. Center block is inscribed with a quote from *Alice in Wonderland,* from which the quilt's title came. Hand-quilted. 110" x 110".
Made for the maker.

120. BALTIMORE ALBUM.
Gerry Sweem.
Reseda, California.
February 1991 to April 1992.
Sixteen hand-appliquéd blocks in red and green print fabrics on a parchment-colored background. Surrounded by a red reverse appliquéd Scrollwork border. 100%-cotton fabrics. Blocks hand-quilted with ½" cross hatch quilting; the border with echo quilting. 79" x 79".
Made for the maker and her daughter, Shelby.

121. WORDS OF LIFE.
Kathy Siuta.
Cockeysville, Maryland.
October 1991 to September 1993.
A Bird, Book, and Basket Medallion center surrounded by 12 blocks that use the entire color wheel with red and green predominating. Blocks are separated by a 1" red-print sashing. The border with twining red ribbon and two angels holding a heart is an original design celebrating the wedding of the maker's son. Primarily 100%-cotton fabrics; also Chinese silk and rayon ribbon. Inked inscriptions in black and brown; includes autograph of Elly Sienkiewicz. Hand-quilted.
87" x 87".
Made for the maker and her descendants.

"Sometimes I said it in ink and sometimes it was just there in the stitches. Someday, someone else may view my quilt and share my memories and because of that possibility, I know that I really made this quilt for me. The making, the having is enough."
—Nadine Thompson, Quiltmaker, Pleasanton, California.

122. BALTIMORE MOURNING.
Leona B. Pancoast.
Pennsville, New Jersey.
April 1991 to August 1993.
Hand-appliquéd Dove, Book and Basket Medallion center with 12 surrounding blocks in red and green. Blocks are separated by a 1" green sashing. Green and red Swag with Hearts and Bows border edged with a green Dogtooth triangle border on the inside and a red Dogtooth triangle border on the outside. 100%-cotton fabrics including hand-dyed ones. Hand-quilted.
94½" x 94½".
Made for the maker and her four sons in memory of her daughter Christina.

123. WHERE YOU TEND A ROSE.
Lisa D. McCulley.
Patuxent River, Maryland.

June to October 1993.
Nine machine-appliquéd Album blocks set in a yellow Eight-Pointed Feathered Star. Roses fill the star's center and bunches of grapes are in each star point. A Grapevine border is enhanced with feather quilting. Binding is yellow. The star design was computer drafted and machine-pieced. Embroidery by hand and machine. 100%-cotton fabrics, some hand-dyed; hand-painted silk. Monofilament thread, Sulky Rayon, and Sulky Metallic threads. Inscriptions made with colored calligraphy inks. Machine-quilted.
68" x 68".
Made for the maker's husband, Stephen Curtis McCulley, to celebrate their 15th wedding anniversary.

124. BALTIMORE BEAUTY.
RoseMarie Allison.
Hatboro, Pennsylvania.
1991 to 1993.
Twenty-five hand-appliquéd blocks predominantly in reds, greens, and blues with a soft yellow background, and red print sashing with white cornerstones. The center block silhouettes Columbus' ship, the Santa Maria, to celebrate the 500th anniversary of the discovery of America. A Hammock and Bow border is edged with a red Dogtooth triangle border on the inside. Two of the blocks feature *Broderie Perse.* Incription from Elly Sienkiewicz to the maker. Hand-quilted.
105" x 105".
Made for the maker.

125. ONE DAY AT A TIME ALBUM QUILT.
Eleanor J. Eckman.
Lutherville, Maryland.
September 1990 to April 1993.
Hand-appliquéd Bird, Book, and Basket Medallion center with 12 surrounding blocks separated by 1" rose sashing. Blocks are surrounded by a red and green Heart and Swag border with a scalloped binding. Primarily 100%-cotton fabrics. Inscriptions on all blocks. Hand-quilted.
86" x 86".
Made for the maker.

126. BACK HOME TO BALTIMORE.
Diana L. Harper.
Baltimore, Maryland.
1990 to 1993.
Hand-appliquéd Peony Medallion center
surrounded by 12 blocks and three bor-
ders in red, white, and red. Irish lace
crocheted flower in Rose Lyre block
was crocheted by maker's mother, also a
Baltimore native, when she was first
married. Hand-quilted.
88" x 88".
Made for the maker.

127. ANDERSON ALBUM QUILT.
Ann Arbuckle.
Anderson, California.
1991 to May 1993.
Twelve hand-appliquéd blocks in green,
fuchsia, pink, purple, and white with
machine-applied red sashing and a Dou-
ble Swag and Tie border. 100%-cotton
fabrics. Each block is hand-quilted in a
different design including trapunto and
stipple quilting.
71" x 85".
Made for the maker and her descen-
dants.

128. BEAUTIFULLY BALTIMORE.
Dale B. Schofield.
Ossipee, New Hampshire.
June to September 1993.
Five diagonally set, machine-appliquéd,
and hand-embroidered blocks with four
half blocks and four quarter blocks,
surrounded by an elaborate Grapes and
Leaves border. 100%-cotton fabrics with
French-wire ribbon roses and three-di-
mensional leaves. Hand-quilted, includ-
ing trapunto.
65" x 64".
Made for a class sample.

129. FAIR HILL BEAUTY.
Sandra S. Bryant.
Elkton, Maryland.
March 1991 to June 1993.
A multi-colored, hand-appliquéd Bird,
Book, and Basket Medallion center, sur-
rounded by 12 red and green blocks
separated by 1" green sashing. Red and
green Heart and Swag border edged
with a green Dogtooth triangle border
on the inside and a red Dogtooth trian-

gle border on the outside. 100%-cotton
fabrics. Hand-quilted.
94" x 94".
Made for the maker.

130. REMEMBER.
Ann Brown Christy.
Laurel, Maryland.
1990 to 1993.
Sixteen hand-appliquéd blocks separated
by red sashing. Four center blocks form
a Peony Medallion. A red and green
Heart and Swag border with red Floral
Sprays at the corners. Includes a Statue
of Liberty block that commemorates the
participation by the maker's daughter in
the All-American College Statue of Lib-
erty Marching Band for the statue's
rededication, July 4, 1986. 100%-cotton
red and green fabrics. Hand-quilted.
90" x 90".
Made for the maker's daughter, Miriam
Christy Loughry.

*"The quilt and I have been
through some difficult times. I will
remember the sadness and pain,
but also the joy, excitement, and
satisfaction I had making it."*
—Ruth H. Meyers, Quiltmaker,
Dhahran, Saudi Arabia.

131. BALTIMORE ALBUM.
Ardeth Laake.
Belmond, Iowa.
October 1992 to May 1993.
Hand-appliquéd Bird, Book and Basket
Medallion center with 16 surrounding
blocks in multi-colors. 100%-cotton
fabrics. Inscriptions include Elly Sien-
kiewicz's autograph. Hand-assembled
and hand-quilted with feather border.
75" x 75".
Made for one of the maker's five grand-
children (with plans to make one for
each of the others).

132. BALTIMORE LEGACY.
Carol Latimer.
Weatherford, Texas.
September 12, 1989 to September 27,
1992.

Twenty-five hand-appliquéd blocks with
many ruched silk flowers. A Cherry and
Leaf border on the sides, a Running
Vine border at the bottom, and a Cen-
tered Floral Cluster with Leafy Vines at
the top, all edged by a red Scalloped
border on both sides. 100%-cotton
fabrics. Hand-quilted.
83" x 83".
Made for the maker and her descendants.

133. BALTIMORE ALBUM QUILT.
Lora D. Pasco.
Atlanta, Georgia.
April 1991 to September 1992.
Twenty hand-appliquéd blocks in pinks
and greens, set with 3" green sashing,
and a 12" pink Double Swag and
Flower border. 100%-cotton fabrics.
Hand-quilted.
102" x 123".
Made for the maker.

134. MINNESOTA FAMILY ALBUM
QUILT.
Lucy K. Brown.
Rochester, Minnesota.
1991 to August 1993.
Nine hand-appliquéd red and green
blocks with 2" red and white pieced
Diamond sashing. The blocks are sur-
rounded by an appliquéd Vine and
Flower border. Some hand embroidery.
100%-cotton fabrics and thread. Inscrip-
tions were written with black Pigma
Pen ink. Hand-quilted.
69" x 69".
Made for the maker's family.

135. BALTIMORE BEAUTY REVISITED.
Frances Abell Brand.
West Dennis, Cape Cod, Massachusetts.
1990 to August 1993.
Twenty hand-appliquéd blocks with
hand-lettered inscriptions in ink made to
commemorate the maker's marriage to
Howard Earnest Brand and their 50th
anniversary. White border elaborately
quilted with a Swag, Feather Spray,
Bow, and Bell, and edged with a red
Dogtooth triangle border on the outside.
100%-cotton fabrics in reds, greens, and
blues. Hand-quilted.
86" x 103".
Made for the maker.

136. BALTIMORE MEMORIES.
Nadine Elizabeth Wareham Thompson.
Pleasanton, California.
1993.
Twenty-five multi-colored hand-appliquéd blocks with calligraphy inscriptions. The green Vine border with red floral sprays in the corners is the maker's design. Primarily 100%-cotton fabrics; also China silk, rayon seam tape, *crêpe de Chine*, hand-painted silk, shaded French ribbons. Hand-quilted with silk tailoring thread.
98½" x 98½".
Made for the maker.

137. BALTIMORE OPULENCE.
Muriel G. Stanley.
Rochester, New York.
1993.
Nine hand-appliquéd blocks on pale yellow backgrounds with red and white pieced Double Diamond sashing and an appliquéd blue print Vine border edged with a dark floral-printed Stepped border on the outside. 100%-cotton fabrics. Hand-quilted with silk thread.
89" x 89".
Made for the maker.

138. SKINNY STEMS AND DINKY BERRIES (THE GRAPE QUILT).
Lisa Schiller.
Houston, Texas.
1991 to 1993.
Nine hand-appliquéd blocks in purples, corals, and olive green, separated by green sashing with red cornerstones. A Grapevine border edged with a red appliquéd Ruffled border on both sides. Hand-quilted.
63" x 63".
Made for the maker and her family.

139. MY HEART OF HEARTS.
Lisa Schiller.
Houston, Texas.
1991 to 1993.
Hand-appliquéd burgundy and green Heart blocks and Fleur-de-lis blocks with border-print sashing and burgundy cornerstones. A print Hammock and Bow border is edged on the outside with the same border-print used in the

sashing. Hand-quilted.
61" x 61".
Made for the maker's daughters.

140. BALTIMORE ALBUM.
Charlcie Lankford.
Fort Worth, Texas.
1990 to 1991.
Sixteen hand-appliquéd predominantly red and green blocks on gray backgrounds with plaid sashing and red cornerstones. Four center blocks form a Peony Medallion. Red and green Peony and Hammock border with Floral Sprays in the corners and edged with a red Dogtooth triangle border on the inside and a green Dogtooth triangle border on the outside. 100%-cotton fabrics. Inscriptions in brown Pigma Pen. Hand-quilted.
94" x 94".
Made for the maker's family.

"At this moment, I am overtired, delinquent in meal planning, household chores, and garden-tending.... But I also have such a feeling of elation and self-satisfaction in meeting my goal [of finishing my Baltimore Album Quilt] and taking some time for myself."
—Nancy Winkler, Quiltmaker, Brookfield, Wisconsin.

141. SERENDIPITY.
Susan Repp.
Haughton, Louisiana.
September 1989 to December 25, 1992.
Sixteen hand-appliquéd blocks with burgundy sashing and navy cornerstones. Serpentine Vine with Roses border with a narrow outer burgundy border. 100%-cotton fabrics, silk, satin ribbon, florist's wire ribbon; embroidery and hand inking. Hand-quilted.
80" x 80".
Made by the maker, an active-duty Air Force officer, for an unknown recipient (as yet).

143. TRADITIONAL BALTIMORE ALBUM QUILT.
Emily Farrell Koon.
Marcellus, New York.
1992.
Twelve hand-appliquéd blocks in predominantly red, green, and blue on white. 10" red-print and green-print Peony and Hammock border. 100%-cotton fabrics, silk, and gold lamé. Hand-quilted.
65" x 80".
Made for the maker's family.

**CATEGORY NO. II.:
BEAUTIFULLY INNOVATIVE**
(sponsored by *Quilter's Newsletter Magazine*)

400. BALTIMORE AND WAYNE ALBUM QUILT.
Shirley Sutton-Smith.
Wayne, Pennsylvania.
1991 to 1992.
Twenty-five multi-colored hand-appliquéd blocks with red sashing and a wide border of appliquéd flowers. Tree blocks in the four corners. Hand quilted.
80" x 80".
Made for Shirley and Brian Sutton-Smith.

401. HEATHER.
Christine Hansen Kmak.
Leesburg, Virginia.
January 1992 to July 1993.
Hand-appliquéd Eagle medallion center bordered with red Scrollwork, 12 hand-appliquéd blocks, and another larger red Scrollwork border. The borders were inspired by this contest's announcement notice. 100%-cotton fabrics.
76" x 76".
Made for Heather Lucile Kmak.

402. ALBUQUERQUE ALBUM VIA BALTIMORE.
Patricia K. Drennan.
Albuquerque, New Mexico.
January 1991 to 1993.
Hand-appliquéd medallion center with a tree and dog in a red frame, surrounded by 12 blocks separated by narrow red print sashing. An elaborate red print

border has appliquéd sunflowers and a large blue print bow at the top and a floral spray with butterflies at the bottom. The Winter and Summer blocks are the maker's designs. 100%-cotton fabrics. Inked inscriptions made with Pigma pens. Hand-quilted.
80" x 80".
Made as a memorial for the maker's son, Ted (Teddy) William Drennan.

403. MEDALLION COPY-CATS.
Sarah's Quilters: Gloria Adriance, Bessie Albonetti, Mary Alfaro, Suzanne Druss, Ursula Hild, Becky Huang, Anita Irwin, Beverly Jennings, Schunke Lynch, Win Moore, Margaret Ritter, Carol Straub, Claudia Straub, Leni Wiedenmeier, and Betty Williamson.
Galveston, Texas.
Finished May 1993.
Thirteen hand-appliquéd paper-cut pattern blocks in reds and greens on a white background. One block used as a central medallion and all blocks set on point with green sashing and a geometric floral border on a white background. Designed, assembled and made by Sarah's Quilters, which includes two "bees," a day group (Sunshine Quilters) and a night group (Heritage Quilters). 100%-cotton fabrics.
80" x 80".
Made in memory of Sarah Williams (1807-1860) for the 1839 Samuel May Williams Home on Galveston Island, Texas.

404. DEO SOLI GLORIA ["TO GOD ALONE GIVE GLORY"].
Cindy Notarianni Swainson.
Scarborough, Ontario, Canada.
1990-1992.
Hand-appliquéd rectangular floral medallion center with angels, surrounded by 14 blocks framed narrowly in red with white background sashing. A red and green Triple Swag and Floral Tassel border on three sides with a Flowering Vine border and family portrait medallion on the top border. 100%-cotton fabrics. Inked inscriptions and faces. Hand-quilted by Mary Gingrich.
83½" x 93½".
Made for the maker.

405. HARPS AND FLOWERS.
Ruth H. Kistler.
Eugene, Oregon.
1991 to 1993.
Nine Lyre (or Harp) and six Wreath blocks hand-appliquéd in pastel pinks and greens on a cream background, alternated with plain blocks and set on point with a Triple Swag and Bow border. 100%-cotton fabrics. The Harp blocks represent the maker's family members who are church musicians. Hand-quilted.
86" x 98".
Made for the maker.

"Each morning around five o'clock I was at my kitchen table with my coffee and my quilt. I seldom thought of the end product. I sewed each day, 'one day at a time,' enjoying the process."
—Eleanor Eckman, Quiltmaker, Lutherville, Maryland.

406. TRADITIONAL BALTIMORE ALBUM.
Hazel B. Reed Ferrell.
Middlebourne, West Virginia.
1989-1992.
Hand-appliquéd red and green Peony Medallion center made up of four blocks surrounded by 12 more multi-colored blocks, all separated by green sashing with red cornerstones. A green and red Swag and Bow border edged with a red Dogtooth triangle border on the inside and a green Dogtooth triangle border on the outside. 100%-cotton and poly-cotton fabrics. Hand-quilted.
78" x 78".
Made for the maker's daughter, Elizabeth Mae Ferrell Audley.

407. BUTTERFLIES BEYOND BALTIMORE.
Sandy L. Broering.
Rising Sun, Indiana.
Summer 1993.
Machine-appliquéd center wreath in greens, pinks, mauves, gray, and blue, surrounded by 12 Rose Lyre blocks set

on point. Four more wreaths fill the large corner setting triangles, surrounded by a purple, green, and blue Triple Swag and Bow border. 100%-cotton and poly-cotton fabrics. Machine-quilted.
92" x 92".
Made for the maker.

409. MY FAVORITE BALTIMORE BEAUTIES.
Karen Larsen-Bray.
Walnut Creek, California.
March 6 to July 3, 1993.
Nine machine-appliquéd and machine-embroidered blocks in greens, burgundys, pinks, and gold. The floral spray borders are adapted from three designs in the quilt blocks. 100%-cotton fabrics. Hand outline-quilting around motifs and crossed diagonal lines on background.
60½" x 60½".
Made for the maker's family.

410. MEMORIES OF BALTIMORE.
Cindy Lammon.
St. Charles, Missouri.
November 1990 to November 1992.
Twelve hand-appliquéd blocks with narrow blue frames and white background sashing. A 9" appliquéd Flowering Vine border. 100%-cotton fabrics in blue, green, red, and pink prints. Machine-assembled and hand-quilted.
76" x 88".
Made for the maker.

411. BALTIMORE REVISITED.
Kathy Bender-Dahme.
Black Hawk, South Dakota.
1992 to 1993.
Twenty hand-appliquéd red and green blocks with 1" red Garden Maze sashing and a red and green Bow, Peony, and Hammock border. 100%-cotton fabrics. Machine-assembled and hand-quilted.
84" x 100".
Made for the maker.

412. TO THE GLORY OF GOD.
Kathy Wesley Smith.
Round Rock, Texas.
September 1991 to July 1993.
Sixteen hand-appliquéd multi-colored and red and green blocks with red sashing and white cornerstones. A 12" red

and green Heart and Swag border edged with red Dogtooth triangle borders on both sides. Inscriptions and finishing touches in ink on some blocks. Hand-quilted.
83" x 83".
Made for the maker.

414. BALTIMORE AVEC LA MACHINE À COUDRE.
Patricia L. Styring.
St. Augustine, Florida.
1993.
Nine machine-appliquéd blocks sashed in red with yellow cornerstones. Curling Rose Vine side borders and Tied Vine Bouquets on top and bottom borders are the maker's original designs. 100%-cotton fabrics. Machine-quilted.
68" x 68".
Made for the maker.

415. SIMPLY BEYOND.
Virginia R. Smith.
St. Simons Island, Georgia.
July 19, 1993.
Twenty hand-appliquéd blocks in red and green on white with a quilted pillow tuck below the first row of blocks and wide white background sashing between blocks. An 11" Hammock and Bow border. 100%-cotton fabrics. Inked inscriptions in some blocks. Hand-quilted with feathered vines between blocks.
78" x 106".
Made for the maker.

416. CALIFORNIA POPPIES FOR BRITTANY.
June Huntridge and Donalene H. Rasmussen.
San Diego, California.
1993.
Hand-appliquéd Floral Basket Medallion center surrounded by 10 blocks set on point. Two half blocks with birds at sides, and four larger corner triangles with Floral Sprays. A 12" Cherry and Leaf Garland border. 100%-cotton, cotton sateen, and damask fabrics. Hand-quilted.
90" x 110".
Made for one of the maker's grand-daughters, two-year-old Brittany Elisabeth Huntridge.

417. MY MOODY BLUE BALTIMORE QUILT.
Mary Lou Dailor.
Fairport, New York.
Finished January 14, 1992.
Sixteen hand-appliquéd blocks in sapphire blue, chocolate brown, and light olive green. Wide white sashing with olive green edges and appliquéd cornerstones. Scalloped border. 100%-cotton fabrics. Hand-quilted.
85" x 85".
Made for the maker's children.

"The further I got along on the quilt, the less the tears fell. A quiet peace came over me, and I knew this quilt was a memorial to [my daughter] Christina's life rather than her death, although in the very beginning I did not know this was the reason I was making it."

—Leona Pancoast, Quiltmaker, Pennsville, New Jersey.

418. EVOLUTION.
Barbara L. Pudiak.
Fairport, New York.
Fall 1992 to Winter 1993.
Sixteen hand-appliquéd blocks that are the maker's original designs (with some based on traditional patterns). Several floral blocks include three-dimensional flowers. White border with quilted Morning Glory Vine edged with a border print strip on the inside and a wider appliquéd border print on the outside. 100%-cotton fabrics along with Ultra-suede™ and silk ribbon. Hand-quilted.
65" x 65".
Made for the maker's family.

420. THE PROGRESSIVE ALBUM.
Betty Alderman.
Mansfield, Ohio.
1989 to 1993.
Nine hand-appliquéd blocks with green print sashing and red cornerstones. An original-design Cherry Vine with Pineapples and Redbirds border edged with a green print Dogtooth triangle border

on the inside. Some blocks are the maker's original designs adapted from 19th-century quilt motifs. 100%-cotton fabrics. Hand-quilted.
65½" x 65½".
The second of three Album quilts, one made for each of the maker's children.

421. "AI," MY MOTHER.
Ethel Yuriko Imamura Howey.
San Antonio, Texas.
January 1990 to July 1993.
Twelve paper-cut hand-appliquéd patterns including two family crest blocks with photos of the maker's parents. Blocks separated by sashing and surrounded by a Fan border. Made as a tribute to the maker's mother, Ai Yasuda Imamura. 100%-cotton fabrics, mostly blue *yukata* (summer cotton) fabrics from Japan. Hand-quilted.
79" x 95".
Made for the maker's youngest sister, Irene Emiko Imamura Matsumoto.

422. LARGE STREAMS FROM LITTLE FOUNTAINS FLOW.
Wanda J. Shanklin.
Arlington, Virginia.
Finished July 1993.
Hand-appliquéd center block with a garland-covered fountain, surrounded by an inner Folded Ribbon border. Center is surrounded by 12 square and two rectangular hand-appliquéd blocks, and an outer Folded Ribbon border. Thai silk used for the fuchsia pieced-ribbon borders. Other fabrics include Ultrasuede™, cotton, polyester, acetate, and velvet; also used are novelty cordings, beads, ribbons, and fabric buttons. Title is from a 1791 poem by David Everett. Hand-quilted.
86" x 86".
Made for the maker.

425. WREATHS, ROSES, AND RIBBONS.
The Mississippi Valley Quilters Guild.
Davenport, Iowa.
August 1991 to April 1992.
This Quad City Album Quilt, "a traditional design executed in an untraditional manner," has 16 hand-appliquéd blocks with the four center blocks forming a Peony Medallion. Pink sashing and

purple cornerstones separate the blocks. All surrounded by a 13½" hand-appliquéd Double Twirling Swag border. 100%-cotton hand-dyed fabrics. Hand-quilted. 92" x 92".
Made as a fund-raising raffle quilt when the guild hosted the 1993 NQA show in Davenport, Iowa, on June 24-27.

426. HANA-1993.
Yumiko Hirasawa.
Kohoku-ku, Yokohama, Japan.
Finished June 24, 1993.
Hand-appliquéd multi-colored roses and tulips are arranged in eight baskets, five vases and seven flower wreaths with green sashing and red cornerstones. Surrounded by an elaborate Scrolled Vine With Tulips border. Many blocks are original designs. Hand-quilted.
70" x 82".
Made for the maker's daughter, Namiko Hirasawa.

427. THREADS THAT KEEP US TOGETHER.
The Quiltmakers at Country Stitches: Natalie Abderhalden, Lori Barrison, Gayle Boshek, Rose Marie Boyle, Nancy Brady (of Ohio), Sharyn Cole, Peggy Cox, Terri Daly, Sue Edwards, Linda Gallina (of Minnesota), Barbara Hahl, Cheryl Horn, Donna Hudson (of Pennsylvania), Ausma Merrill, Terri O'Connor, Jean Smith, Josephine Sansone, Patty Trevarthan, Lori Weiss, Lorraine Wright, and Debbie Zurbola.
Coral Springs, Florida.
March to August 1993.
Twenty hand-appliquéd blocks in green-teals, mauves, and pinks. Pink and rose Double Swag With Tulip border edged with a green-teal Sawtooth triangle border on the inside. 100%-cotton fabrics, French silk ribbons, embroidery floss, and seed beads. Inked inscriptions. Hand-quilted with cotton thread.
65" x 78".
Made for "group pride," to be donated to charity.

428. APPLIQUÉ AN HEIRLOOM. BALTIMORE #2.
Marlene Peterman.
West Hills, California.

1990 to 1991.
Four multi-colored hand-appliquéd blocks with a Blue Ribbon and Rose-bud Vine border. 100%-cotton hand-dyed fabric and hand-dyed silk. Hand-quilted with feathered ovals around blocks.
60" x 60".
Made for the maker.

"I see this quilt as a culmination of all I have learned as a quilter over the past 15 years. Rather than an ending, I feel this is a new starting point for me, to feel secure in my abilities as a quilter and to continue to stretch and push myself beyond my comfort level."
—Lisa McCulley, Quiltmaker, Patuxent River, Maryland.

430. A PEACOCK IN THE GARDEN.
Patricia Brundage.
San Manuel, Arizona.
January to September 1993.
Twelve multi-colored hand-appliquéd blocks in offset center framed in dark green. First border contains a Peacock block on the right and an Epergne of Fruit block at the bottom with narrower top and left borders. Surrounded by a Leaf and Berries border. 100%-cotton fabrics, some hand-dyed. Machine-assembled and hand-quilted.
87" x 99".
Made for the maker.

432. A TREE GROWS IN BALTIMORE.
Madonna Auxier Ferguson.
East Lansing, Michigan.
1992 to 1993.
An original-design, hand-appliquéd tree with green leaves, red flowers, and predominantly blue birds overlapping 12 traditional Baltimore Album-style blocks on colored backgrounds. 100%-cotton fabrics, including stripes and plaids, some over-dyed and stenciled. Hand-quilted.
63" x 92".
Made for the maker's family.

434. BALTIMORE COUNTY ALBUM QUILT.
Katherine L. McKearn.
Towson, Maryland.
1991.
Hand-appliquéd, hand-embroidered Medallion center of a basket of vegetables surrounded by a Leaf and Vine border. Center circled by 12 blocks that depict vegetables rather than the more traditional flowers. Blocks surrounded by narrow green and wider white quilted borders. 100%-cotton fabrics. Center block inscription says, "Burpee Gardens 1990." Machine-assembled and hand-quilted.
69" x 69".
Made for the maker.

435. FROM BALTIMORE AND AROUND THE WORLD.
Susan Price Cook.
Coshocton, Ohio.
February 1991 to July 1992.
Hand-appliquéd four-block Peony Medallion center in red and green surrounded by 12 multi-colored blocks separated by a light print sashing. Blocks surrounded by a red and green Peony and Hammock border with Floral Sprays in the corners edged with a red Dogtooth triangle border on the inside and a green Dogtooth triangle border on the outside. 100%-cotton fabrics from around the world, silk batik from Malaysia. Hand-quilted in outline, shadow, stipple, and cross hatch designs.
78½" x 78½".
Made for the maker.

436. TO BALTIMORE, MY WAY.
Sylvia Gentry Richardson.
Marion, Virginia.
1993.
Sixteen hand-appliquéd blocks with several framed family vignettes. A Leaf Vine border incorporating gingko, ivy, and weed leaves from the maker's front yard and edged with a red border and red print Scrollwork frame on the inside and a red print Scrollwork frame on the outside. Hand-quilted.
72" x 72".
Made for the maker's family.

437. A DREAM BEGETS A DREAM.
Ellen Cieslak Sweeney.
South Euclid, Ohio.
1993.
Hand-appliquéd circular medallion center on black background with a red Dogtooth triangle border. The center medallion was planned much like an English knot garden except the vases are the right and left silhouette of the maker's husband, Tom. Elaborately appliquéd Ribbon and Flowering Vine border with a Peacock in the upper left corner and a Cornucopia in the lower right one. 100%-cotton fabrics, some hand-dyed. Hand-quilted.
60" x 60".
Made for the maker and her family.

438. FEAST OF FLOWERS.
Dolores Pulford.
Glen Arm, Maryland.
January 1992 to September 1993.
Fourteen hand-appliquéd blocks that surround a Framed Floral Basket Medallion center. Berry-colored sashing with a Double Swag and Rose Garland border. 100%-cotton fabrics. Hand-quilted.
84" x 97½".
Made for the maker's oldest daughter, Gail.

439. A NEW ENGLAND ALBUM QUILT.
The Good Ladies of Baltimore North and The Cocheco Quilters Guild: Inez Dimambro, Barbara Caswell, Marilyn Follansbee, Jeanne Smart, JoAnn Joy, Faye Labanaris, Susan Savory, Mae Strawbridge, Patience Dixon, Rebecca Hall Metzger, Sharon Howard, Louise Ford, Penny Palmer Parsons, Lynette McCreary, Margaret Grant Thomas Beal, Brenda Farnsworth McAdam, Michele O'Neil Kincaid, Susan Copp Bickford, Patricia M. Tucker Cormack, Linda Scherf, Priscilla Jane Smith Sharp, Frances Witcomb, Kathy G. Box, Jane Carrier, Kathy DesRoches, and Lucinda McKenney.
Dover, New Hampshire.
1991 to 1993.
Twenty hand-appliquéd original-design blocks on ecru backgrounds, with four sky blue borders that represent the flora and fauna of the four seasons. Border is edged with an uneven green Dogtooth triangle border on the inside. Made to celebrate the beauty of New England during the four seasons. Primarily 100%-cotton fabrics, many hand-dyed; also rayon, silk, satin, some metallics. Hand-quilted.
87½" x 97".
Made for The Cocheco Quilt Guild.

440. MELODIES OF LOVE.
Lisa Schiller.
Houston, Texas.
1991 to 1993.
Five hand-appliquéd blocks with musical lyres alternated with four trapunto blocks, separated by sashing. Surrounded by a paisley stripe border. One block made by Diane Foote. Hand-quilted.
53" x 53".
Made for the maker's family.

"I cannot express in mere words the joy I experienced making this quilt. As I look at it today, three years after I completed it, I still love every stitch."
—Charlcie Lankford, Quiltmaker, Fort Worth, Texas.

441. BALTIMORE? TEXAS, U.S.A.
Lisa Schiller.
Houston, Texas.
1991 to 1993.
Four hand-appliquéd Eagle blocks and four pieced Star blocks surround an appliquéd Texas block with red print sashing and red cornerstones. Surrounded by an appliquéd green Double Feather border with red flowers, edged with an appliquéd undulating red print on both sides.
62" x 62".
Made for the maker and her family.

442. BRODERIE PERSE ALBUM.
Beatrice S. Oglesby.
Overland Park, Kansas.
October 1991 to April 1993.
Sixteen hand-appliquéd blocks with Butterscotch backgrounds. Seven blocks were designed by the maker. 6½" appliquéd Rose Spray border edged with deep rose Dogtooth triangle border on the inside. Hand-quilted.
73" x 73".
Made for the maker.

444. LOOK WHAT HAPPENED ON MY WAY TO BALTIMORE.
Laura Reif Lipski.
Lindenhurst, New York.
June 1990 to June 1991.
Machine-pieced Eight-Pointed Star with a hand-appliquéd central Basket Medallion and eight hand-appliquéd blocks between star points. Blue-solid and red-print bows in four corners surrounded by plain blue border and Twining Ribbon and Flower border with corner flower vases. Appliquéd border edged with red Dogtooth triangle borders on both sides. Hand-quilted.
82" x 82".
Made for the maker.

445. EMILY'S BALTIMORE BEAUTY.
Emily Farrell Koon.
Marcellus, New York.
1993.
Twelve hand-appliquéd blocks in predominantly burgundy, pink, and green prints. 10" Dancing Grapevine border. 100%-cotton fabrics, and gold lamé for the Lyre block. Inked inscriptions. Hand-quilted.
65" x 80".
Made for the maker's family.

CATEGORY NO. III.: REFLECTIVE OF PARTICULAR LIVES AND TIMES
(sponsored by Fiskars Manufacturing Corporation)

700. THE TANAKA FAMILY ALBUM QUILT.
Cindy Notarianni Swainson.
Scarborough, Ontario, Canada.
1991 to 1992.
Hand-appliquéd medallion center of the family home surrounded by a floral wreath called "The Garden of the Ancestors" with flora representing various family members. Four corner blocks portray the husband, wife, son, and daughter, with eight more blocks con-

taining designs based on traditional Japanese crests or *mon*. Green sashing and an appliquéd floral border with a Japanese flavor. 100%-cotton fabrics. Hand-quilted by Esther and Rebecca Weber of Waterloo County, Ontario. 81½" x 81½".
Commissioned by Kathryn Ann Creber Tanaka as a gift for her husband, Norris Rei Tanaka, to celebrate their 15th wedding anniversary.

701. SOMEWHERE IN TIME.
Kathryn Miller.
Fresno, California.
September 1989 to 1992.
Sixteen hand-appliquéd multi-colored blocks including several with Baltimore Album style frames around silk-screened portraits of family members and the dog. Green sashing with red hearts appliquéd at cornerstones. Green and red Hammock and Bow border edged with a red Dogtooth triangle border on the inside and a green Dogtooth triangle border on the outside. Hand-quilted.
88" x 88".
Made for the maker.

702. FEELINGS.
Sandra (Sandy) J. Myers.
Gainesville, Georgia.
March 1991 to 1993.
Twelve hand-appliquéd blocks in cream, greens, and reds, some multi-colored, set with green sashing and an appliquéd Rosebud Vine border. 100%-cotton fabrics; also white satin. Two original designs. Inked inscriptions. Hand-quilted.
62" x 76".
Made for the maker's family.

703. CALLAHAM FAMILY ALBUM.
Robert James Callaham.
Orange, California.
1992 to May 1993.
Hand-appliquéd Bird, Book and Basket Medallion center surrounded by a circle of hearts. Medallion circled with 12 blocks in dark green, burgundy, camel and accents of blue, yellow, and pink. Grapes and berries are stuffed appliqué. Dark green sashing with camel cornerstones. White border edged with camel and dark green. Cotton print fabrics.

Inked inscriptions by Kattie Needham. Hand quilting by Va Yang includes cables and feathers in the border.
77" x 79".
Made for the maker's family.

704. SHORE ACRES COMMEMORATIVE QUILT.
Shirley Hammar.
North Bend, Oregon.
July 1991 to October 1992.
Hand-appliquéd medallion center surrounded by Vine border and print frame. Twelve blocks and a pillow tuck that is trapunto-quilted with "Shore Acres" surround the medallion. Border of large and small pieced Grand Fir blocks on sides and bottom. Velvets, silks, hand-marbled and upholstery fabrics, organzas, embroidery, and beadwork. Inked calligraphy by Fr. Martin; "Shore Acres" lettering was done by Bill Blumberg. Hand-quilted, including trapunto.
85" x 85".
Made for the 50th anniversary of Shore Acres Botanical Gardens.

705. CELEBRATION.
Angie G. Purvis.
Fort Benning, Georgia.
January 1, 1992 to March 6, 1993.
Sixteen hand-appliquéd blocks in red and green on off-white, with a green and red Hammock and Bow border. The maker and her husband have moved many times with the U.S. Army and the red sashes in this quilt symbolize the many streets they have crossed. 100%-cotton fabrics. Hand-quilted.
82" x 82".
Made for the maker's husband, Fred.

706. NORTHERN MEMORIES.
Donna Hall Bailey.
Glastonbury, Connecticut.
January to July 1993.
Nine hand-appliquéd blocks with blue print sashing, yellow cornerstones, and a blue print Stepped border. Three vertical center blocks are original designs. 100%-cotton fabrics with some silks and polycottons. Hand-quilted.
68½" x 68½".
Made for the maker.

707. A BOOK LOVER'S ALBUM.
Suzanne Peery Schutt.
Clinton, Mississippi.
1989 to June 14, 1993.
Sixteen hand-appliquéd blocks that document the maker's marriage and special family dates along with favorite quotations from literature. Set together with green Victorian fabric sashes and red cornerstones. Surrounded by a green Swags with Cotton Bolls and Magnolia Buds border edged with a red Dogtooth triangle border on the inside. Hand-quilted.
98" x 102".
Made for the maker's husband, Wallis Joseph Schutt, Sr.

708. AN ALBUM FOR MY MOTHER.
Bess Rude.
Sussex, New Jersey.
April to September 1993.
Twenty-five hand-appliquéd multi-colored blocks set with 1" red sashing and surrounded by a green Swag border edged with a red Sawtooth triangle border on the outside. 100%-cotton fabrics with muslin. Hand-quilted.
86" x 86".
Made for the maker.

709. FAMILY ALBUM.
Marjorie (Marge) Jensen.
Woodbridge, New Jersey.
Finished in 1993.
Nine hand-appliquéd blocks in reds and greens on white background with inked inscriptions for family members. Green and white triple-stripped sashing with appliquéd red and green tulip cornerstones. Surrounded by a green and red Hammock and Bow border. 100%-cotton fabrics. Hand-quilted.
67" x 67".
Made for the maker.

710. BALTIMORE ALBUM NOUVEAU WITH ANGELS.
Patricia L. Styring.
St. Augustine, Florida.
1990 to 1991.
Sixteen hand-appliquéd blocks with a lush Floral Vine border tied at center top and bottom by angels. Traditional reds and greens predominate with four

Basket blocks in the center and many original-design angels. This is the maker's 27th quilt. 100%-cotton fabrics. Inked inscriptions. Hand-quilted.
85" x 85".
Made for the maker.

711. SUNDAY MORNING IN BALTIMORE.
Celia L. Deere.
Charlotte, North Carolina.
October 1991 to July 26, 1992.
White whole-cloth quilt with embroidery and scalloped borders. Center is an adapted version of Victorian Basket V with Fruits and Flowers surrounded by borders adapted from the Four Ribbon Wreath and the Wreath and Dove patterns. The maker's fifth quilt is accompanied by two quilted king-size pillow slips. Hand-quilted.
78" x 86".
Made for Cynthia Westmoreland.

712. A PEARL CELEBRATION.
Nancy Ota.
San Clemente, California.
January 1989 to July 1991.
Fourteen square blue and white hand-appliquéd blocks in sampler style. Two blocks are machine-appliquéd. Bottom center two-block horizontal design includes wedding photograph transferred to cloth by the sublimation process. Horizontal Rose Vine With Birds across pillow area. White border edged with a narrow blue strip on inside and a blue Pieced Ribbon border on outside. 100%-cotton fabrics. Hand-quilted with motifs representing the married couple, including their family crests.
87" x 102".
Made for the maker and her husband, Mike, to celebrate their 30th wedding anniversary.

713. NEW ZEALAND HERITAGE.
Jean Nutter.
Papatoetoe, New Zealand.
November 1992 to June 26, 1993.
Twelve multi-colored hand-appliquéd blocks and a wide appliquéd Floral Swag border filled with New Zealand birds and flowers. Hand-quilted.
65" x 80" [approximate].
Made for the maker.

714. ALDERMAN FAMILY ALBUM.
Florence E. (Betty) Waples Alderman.
Mansfield, Ohio.
1989 to 1992.
Nine hand-appliquéd multi-colored blocks with the center block portraying the maker's family home in Palmyra, New York, and family members. Vine With Cherries, Birds, Bows, and Flowers border adapted from 19th-century quilt design elements. 100%-cotton fabrics. Inked inscriptions. Hand-quilted, including an undulating feather border.
66" x 66".
Made for the maker's family (with plans to make two more so that each of her three children will have one).

"I wish to thank Elly for her commitment to this art form.... I would never have tackled such an endeavor without her inspiration and enthusiasm. Just imagine all the beauty she has released into our world and hopefully these pieces will exist for generations to come and be admired just as we enjoy those magnificent pieces of 150 years ago."
—Shirley Hammar, Quiltmaker, North Bend, Oregon.

715. EIGHTIES LADIES: AN ALBUM QUILT FOR THE TWENTIETH CENTURY.
Beth Thomas Kennedy.
Austin, Texas.
Fall 1990 to 1992.
Hand-appliquéd patriotic medallion center with Eagle and four Cornucopias surrounded by a narrow Dogtooth triangle border. Surrounded by 12 Dogtooth-framed blocks with wide white sashing and a green and red Double Swag border edged with a Dogtooth triangle border on the outside. Heavily inked with quotes regarding war in the medallion and about life in this century in the Swag border. The seventh in the maker's Matriarchal Rituals quilt series. Commercial and hand-dyed cottons, taffeta, chiffon, and ribbon. Hand-

quilted in outline, cross hatch, and feather designs.
90" x 90".
Made for the maker.

716. HERE'S MY HEART 'TIL DEATH DO WE PART.
Marjorie Mahoney.
Battletown, Kentucky.
January 1992 to July 1993.
Thirty hand-appliquéd blocks predominantly in red and green with white sashings and appliquéd red hearts as cornerstones. White border hand-quilted with feathers and hearts. The maker's husband chose many of the blocks in the quilt based on his love for flowers, birds, trees, and all of God's creation. 100%-cotton fabrics. Inked inscriptions.
85" x 98½".
Made as a memorial to the maker's husband, Edward John Mahoney (1902-1992); to be given to the maker's daughter, Gloria Jeanne Peterman.

717. MY BALTIMORE ALBUM QUILT.
Avis Annis Spicer.
Rutland Town, Vermont.
January 1, 1989 to July 19, 1993.
Twenty-five hand-appliquéd blocks in red and green with red sashing and a green and red Hammock and Bow border. The maker's first-grade students reproduced many of her blocks in crayon as each was brought to class. Ruched flowers; inked inscriptions. Hand-quilted by Saloma Miller Furlong of Shelburne, Vermont. Bound by Jeanne Detenbeck, also from Shelburne.
92" x 92".
Made for the maker and her family.

718. A DIFFERENT VOICE.
Rosalynn McKown.
Laurel, Maryland.
January 1 to July 1993.
Twelve hand-appliquéd wreath blocks with inked poems by Emily Dickinson (1830-1886) who lived during the heyday of Baltimore Album Quilts. Includes a silhouette of Dickinson and a sketch of her bedroom in Amherst, Massachusetts. Blocks separated by deep pink sashing and surrounded by a green print and deep pink Swag and Heart border. 100%-cotton fabrics, predominantly

pinks, mauves, and dark aquas. Hand-quilted.
70" x 88".
Made for the maker.

719. GIRARD FAMILY QUILT.
Louise Helen Girard.
Burlington, Ontario, Canada.
January 1991 to April 1992.
Nine hand-appliquéd blocks in bright red, forest green, and cream with Victorian inking in three blocks. Green sashing with red cornerstones and a white quilted border edged on both sides with stylized red maple leaves to denote the family's Canadian heritage. Primarily 100%-cotton fabrics; also satin ribbons. Hand-quilted.
66" x 66".
Made for the maker's family to celebrate the 15th anniversary of her marriage to Michael Christopher Girard on May 21, 1992.

720. PARADISE.
Alexandra G. Barchi.
Downingtown, Pennsylvania.
1993.
Nine hand-appliquéd blocks with white and hand-dyed blue batik pieced Diamond sashing. Includes two original blocks; color photos on fabric in the center block; wide white border. Hand-quilted.
78" x 78".
Made for the maker's children, Erich and Elizabeth Barchi.

721. THE VANDERVEEN/SOARES FAMILY QUILT.
Susan Vanessa Vanderveen.
El Cajon, California.
February 1992 to July 25, 1993.
Hand-appliquéd Basket With Floral Swags Medallion center surrounded by eight appliquéd and four plain blocks and a blue Scalloped Double Swag border. Four corner blocks are signed by the maker and her three siblings; the bottom center block is signed by her parents. 100%-cotton fabrics; also satin, *Broderie Perse,* and embroidery. Hand-quilted with double cross hatch, stuffed, and feather designs.
80" x 95".

Made for the maker's parents, Mr. and Mrs. Robert Vanderveen, to celebrate their 40th wedding anniversary.

722. SQUARE ONE QUILTERS ALBUM: HOMES.
Square One Quilters: Dot Hartley, Dee Addicott, Judy Beman, Nancy Boretos, Mary Ann Clendenin, Amanda Ford, Judy Fredericks, Lois Gawler, Nelda Granum, Donna Martin, Nancy Mae McHugh, Mary Shook, and Gerry Smith.
Bethesda, Maryland.
March 1992 to June 1993.
Twelve blocks by group members surround four center blocks by Dot Hartley, set with red sashing and white cornerstones. Surrounded by a red and green Peony and Hammock border with Floral Sprays in the corners. Dot took photographs of members' homes, and made the inked drawings with a black Pigma pen. Each member then framed the drawing of her home with an Album design and inked an inscription. Five blocks (by Mary Ann, Judy F., Lois, Donna, and Gerry) were hand-appliquéd while the rest were appliquéd on the machine. 100%-cotton prints on muslin. Dot Hartley machine-assembled the top; Edith Chase of Ridgely, West Virginia, did some hand quilting; and then Dot finished the quilting by machine.
90" x 90".
Made for Dot Hartley.

723. FLOWERS OF LOVE.
Sandra Dockstader with Shar Jacobsen, Susanne Benson, and Vici Miller (The Four Musketeers).
Northfield, Minnesota.
February to August 1993.
Oval medallion center with inked picture of a child sharing a rose (symbolizing Love) with another child, surrounded by ivy (Eternal Friendship), oak leaves, acorns and grapes (Seeds of the Future). Twelve hand-appliquéd blocks surround the center and are surrounded by a border of Grapes Tied with Ribbons on three sides and a Rose, Grape, Oak, and Ivy Swag with Ribbon at the top. Three blocks, the

medallion center, and the border were designed by the maker. Her three friends each made one block. 100%-cotton hand-dyed fabrics and commercial prints in dark pink, red, green, and purple on cream background. Inked inscriptions about childhood, raising children, and being a mother. Hand-quilted; trapunto and cording.
79" x 79".
Made for the maker's first child, Josephine (Josie) Cora Dockstader.

724. A MUSICAL HERITAGE.
Edith Zimmer.
San Diego, California.
1993.
Hand-appliquéd medallion center with music stand and a border-print frame edged with a red Dogtooth triangle border on the inside. Surrounded by 12 blocks portraying musical instruments played by the maker, her six siblings, and her father. Musical instruments and symbols drawn by the maker. Finished with red Dogtooth triangle border and and a border print. 100%-cotton fabrics predominantly in red and green. Hand-quilted.
66" x 66".
Made for the maker.

725. BALTIMORE MORE OR LESS.
Jean M. Turner.
Middleton-on-Leven, YARM, Cleveland, England.
1991 to 1993.
Twenty-five hand-appliquéd blocks predominantly in pinks and greens with the maker's home, Foxton Lodge Farm, in the center block. Surrounded by a narrow green border-print border and a wider solid green border. Inked inscriptions. Hand-quilted.
95" x 95".
Made for the maker and her husband.

726. BALTIMORE.
Vivian Kruzich.
Trussville, Alabama.
August 1990 to March 1992.
Sixteen hand-appliquéd blocks with red print sashing and gray print cornerstones. Surrounded by a gray and red Hammock and Bow border edged with

red Dogtooth triangle borders on both sides. Includes hand-dyed silk, grapes stuffed with silk batting, metallic thread for buttonhole stitching. Silhouettes, signatures, and inscriptions done with Pigma pen. Hand-quilted.
84" x 84".
Made for the maker and her children.

727. A TRIBUTE TO CELIA THAXTER (1835-1894).
Faye Samaras Labanaris.
Dover, New Hampshire.
1993.
Five hand-appliquéd blocks, four half blocks, and four quarter blocks, set on point. The blocks are surrounded by a dark Dogtooth border and a wide floral border (with a bow at the bottom) on sky blue fabric. The blocks represent Celia Thaxter's life and include inked inscriptions from her poetry; the border represents her beloved Appledore Island garden, "a most breathtaking riot of color." 100%-cotton fabrics; also hand-painted cotton and silk fabrics, *peau de soie,* French wired silk ribbon, grosgrain ribbon, beads, buttons, trims, laces, and metallic threads. Hand-quilted. (Detail on the cover.)
68" x 68".
Made for the maker.

728. OUR 40TH ANNIVERSARY QUILT.
Martha F. Albert with Sandy Miller and Dawn Moshier.
Falls Church, Virginia.
January 19, 1991, to January 28, 1993.
Sixteen hand-appliquéd blocks with Floral Vine border. Cotton fabrics in burgundy, aqua, green, gold, lavender, and purple. Inked inscriptions by Sandy Miller of Annandale, Virginia. Hand-quilted by Dawn Mosier of Castorland, New York.
70" x 70".
Made for the maker's husband, Richard F. Albert.

729. WILSON FAMILY ALBUM QUILT.
Kathleen Elizabeth Wilson with the Assumption Quilters.
St. Charles, Missouri.
Spring 1990 to September 1993.
Twelve hand-appliquéd blocks on a tea-dyed tan background surrounded by a strip of fuchsia and a tuck of emerald. The Floral Spray border has hand-appliquéd vines with folded rosebuds and bows. The silhouettes are of the maker's two daughters, Cori and Micki, and the inked portrait of the family home was made by the maker's husband, Mike. Cotton fabrics. Includes inked inscriptions, ruching, stuffed berries, buttonhole embroidery, superfine stems, folded rosebuds, and reverse appliqué. Machine-assembled by the maker. Hand-quilted by the Assumption Quilters of O'Fallon, Missouri, and by the maker.
93" x 112".
Made for the maker's family.

730. KINNIKINNICK CREEK ALBUM.
Katherine L. McKearn.
Towson, Maryland.
1993.
Nine hand-appliquéd multi-colored blocks that portray childhood memories. Surrounded by a red print undulating frame on a green border. Hand-dyed cotton fabrics along with rubber-stamped images and photocopy transfers; also includes wire ribbon, rayon fringe, braid trim, rick rack, and perle-cotton embroidery. Machine-assembled and hand-quilted.
59" x 63".
Made for the maker.

731. AUTUMN ALBUM.
Marjorie Haight Lydecker.
Dennis, Massachusetts.
September 1992 to 1993.
Hand-appliquéd Yankee Rose medallion center on point surrounded by Streak of Lightning border. Surrounded by 16 hand-appliquéd octagonal blocks in brown, blue, gold, and off-white, with geometric sashing designed by the maker. Another Streak of Lightning border follows, along with a 6" border-printed border. 100%-cotton fabrics. Hand-quilted.
93" x 93".
Made for the maker's husband, Kenneth R. Lydecker.

732. BALTIMORE ALBUM SAMPLER.
Barbara S. Kopf.
Bethesda, Maryland.
September 1991 to September 1993.
Twenty-five hand-appliquéd multi-colored blocks with blue frames and white sashing. A 6" appliquéd Vine with Flowers and Bows border. Center block, designed by maker's daughter-in-law, portrays view from New Hampshire retirement home window. 100%-cotton fabrics; also includes Ultrasuede™.
Hand-quilted.
108" x 108".
Made for the maker and her husband.

733. 745 TANK BATTALION ALBUM QUILT.
June Dixon.
Arthur, Illinois.
Spring 1989 to 1991.
Twenty-five hand-appliquéd patriotic blocks with World War II information and logos in tan, red, and green, with red sashing and white cornerstones. Red and green Star and Swag border edged by red Dogtooth triangle borders on both sides. 100%-cotton fabrics. Hand-quilted by the maker and Ellie Mae Miller of Arthur, Illinois.
90" x 90".
Made for the maker's husband, Robert.

734. [HERE'S TO YOU, ELLY—] THIS BUD'S FOR YOU.
Patricia A. Timms.
Rochester, Minnesota.
Finished August 28, 1991.
Nine hand-appliquéd blocks with teal and white pieced Diamond sashing. Inner white border has hand-quilted cables and feathers; outer Boston Commons border uses green/teal and rose/pink fabrics. 100%-cotton fabrics. Inked inscriptions. Hand-quilted.
80" x 80".
Made for the maker, her husband, George, and her family.

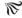

Elly Sienkiewicz, Author, The *Baltimore Beauties* Series.
Photo by Allan Gerson

*"As I travel around the country and take pictures of
quilts, I am discovering more and more quilts made
in the Baltimore Album style. Most of these quilters
credit you for the inspiration for their quilts and for
the methods they use to make them."*
—Jean Eitel, Editor, Harris Publications, Inc.,
Letter to the Author, 1993.

*"I love all your Baltimore books—mostly because
you do such a good job of conveying the feeling of
being spiritually tied to every quilter, historical and
contemporary."*
—Shirley G. Keaough, Letter to the Author,
1993.

Elly Sienkiewicz is a quiltmaker, teacher, and
author whose interests in art, history, and reli-
gion are well met in the mid-19th-century
Baltimore Album Quilts. With degrees from
Wellesley College and the University of
Pennsylvania, she has for a dozen years now,
written about the Album Quilts. Her percep-
tion of these quilts is informed by historical
research and a kindred quiltmaking passion.
Elly's *Baltimore Beauties* series combines faith-
fully reproduced antique patterns with artistic
"beyond Baltimore" interpretations. With
clarity and inspiration, her books twine
how-to instruction together with history
and insight into the very souls of the Album

Quilt-makers themselves. A long-time resi-
dent of Washington, D.C., and Turtle Hill,
Little Round Bay on the Severn River in
Maryland, Elly is well-situated to pursue
study of these antique Maryland quilts she
loves so well.

TEN BOOKS BY ELLY SIENKIEWICZ

With the exception of her first, self-published
book, all of the author's books are available
from C&T Publishing, P.O. Box 1456,
Lafayette, California, 94549. 1-800-284-1114

*Spoken Without A Word—A Lexicon of Selected
Symbols With 24 Patterns from Classic Baltimore
Album Quilts* (1983). This was the first book
to faithfully reproduce patterns from classic
Baltimore Album Quilts and to point out the
intentional symbolism within these quilts' de-
sign motifs. (Available from Vermont Patch-
works, Box 229, Shrewsbury, VT 05738.
1-800-451-4044)

*Baltimore Beauties and Beyond, Studies in Classic
Album Quilt Appliqué, Volume I* (1989).
Twelve lessons take the beginner from the
simplest Baltimore Album Quilt blocks to the
most complex. A wealth of appliqué tech-
niques is presented and 24 Album block pat-
terns are given. Already a classic, this book
introduces you to Baltimore-style Album
making.

*Baltimore Album Quilts, Historic Notes and An-
tique Patterns, A Pattern Companion to Baltimore
Beauties and Beyond, Volume I* (1990). A mag-
nificent 56 patterns offer the framework for
sharing Baltimore's fascinating historical saga
and closeup pictures of antique blocks and
Albums.

*Baltimore Beauties and Beyond, Studies in Classic
Album Quilt Appliqué, Volume II* (1991). This
volume pictures more than 50 antebellum
Albums and offers 20 block and 13 border
patterns. It teaches the design and making of
Picture Blocks and instructs on how to write
on your quilts in permanent ink, including
the transfer of engraved motifs by ironed-on
photocopies.

Appliqué 12 Easy Ways! Charming Quilts, Giftable Projects, and Timeless Techniques (1991). A very basic how-to-appliqué book illustrated with wonderful clarity. Complete patterns include 29 beautiful projects from gifts to graphic museum replica quilts. Their common thread? All are terrifically appealing and so easy to make! Written for the novice, this book has proven equally popular among experienced appliquérs wishing to learn Elly's "latest pointers" on appliqué.

Design a Baltimore Album Quilt, A Design Companion to Volume II of Baltimore Beauties and Beyond, Studies in Classic Album Quilt Appliqué (1992). How do you set your diverse Album blocks into a magnificent quilt? What border suits them best? Elly's ingenious book provides 18 easy lessons and miniaturized blocks and borders for a unique "cut and paste" Album Quilt design system. Then there are instructions for how to make several antique bindings and all the patterns (including a border) for a lovely 25-block antique Baltimore Album Quilt.

Dimensional Appliqué—A Pattern Companion to Volume II of Baltimore Beauties and Beyond, Studies in Classic Album Quilt Appliqué (1993). A best-seller! Simple, innovative methods for dimensional flowers and unique appliqué basketry. All are taught through step-by-step teach-yourself lessons, dozens of block patterns and five border patterns. Whether for stylish accessories or an heirloom quilt, with this book, exquisite flowers bloom at your fingertips!

Baltimore Album Revival! Historic Quilts in the Making—Catalog of C&T Publishing's Baltimore Revival Album Quilt Show and Contest (1994). This catalog documents an historic exhibition and contains an essay as insightful as it is entertaining, analyzing why Baltimore-style Album Quilts have become so popular once again.

Appliqué 12 Borders and Medallions! A Pattern Companion to Volume III of Baltimore Beauties and Beyond, Studies in Classic Album Quilt Appliqué (1994). Here are a dozen patterns—fully drafted out and pictured in fabric—for some of the most beautiful fruit and floral borders in the classic Albums. Two magnificent—and easy—enlarged central medallion patterns are included: one from Baltimore, one from "beyond."

Baltimore Beauties and Beyond, Studies in Classic Album Quilt Appliqué, Volume III (1995), Paper-cut Appliqué Albums have always been the author's favorite stylistic stream in the antebellum Baltimores. Having saved the best for last, Elly offers a crescendo finish to this remarkable series. *Volume III* offers an in-depth study of how to make Albums in this surprisingly expressive style plus intriguing lessons on "Fabulous Fruits." Included in this final volume is a fascinating historical analysis of what caused the Baltimore Albums to bloom so profusely, who made these famous quilts, why the style spread so widely, and what brought the Album era to an end?

Other Fine Quilting Books are available from C&T Publishing. For more information write for a free catalog from

C&T Publishing
P.O. Box 1456
Lafayette, CA 94549
(1-800-284-1114)